Talk Sexy
to the One
You Love

Talk Sexy to the One You Love

(and Drive Each Other Wild in Bed)

BARBARA KEESLING, Ph.D.

HarperPerennial
A Division of HarperCollins*Publishers*

A hardcover edition of this book was published in 1996 by Harper-Collins Publishers.

TALK SEXY TO THE ONE YOU LOVE. Copyright © 1996 by Barbara Keesling. All rights reserved. Printed in the United States of America. No part of this book may be used or reproduced in any manner whatsoever without written permission except in the case of brief quotations embodied in critical articles and reviews. For information address Harper-Collins Publishers, Inc., 10 East 53rd Street, New York, NY 10022.

HarperCollins books may be purchased for educational, business, or sales promotional use. For information please write: Special Markets Department, HarperCollins Publishers, Inc., 10 East 53rd Street, New York, NY 10022.

First HarperPerennial edition published 1997.

Designed by Alma Hochhauser Orenstein

The Library of Congress has catalogued the hardcover edition as follows:

Keesling, Barbara.
 Talk sexy to the one you love : (and drive each other wild in bed) /
Barbara Keesling.
 p. cm.
 ISBN 0-06-017211-8
 1. Sex instruction for women. 2. Women—Sexual behavior.
3. Communication in sex. 4. Sexual excitement. I. Title.
HQ46.K425 1996
613.9'6—dc20 95-37150

ISBN 0-06-092802-6 (pbk.)

05 06 ❖/HC 15

Contents

Introduction

SHARON is never at a loss for words. She knows how to use words to say what she means and get what she wants. It's how she makes her living. Sharon writes grant proposals, and everyone she works with admires her special talents. But Sharon isn't at work right now—she's at home with her husband Richard. And there it's an entirely different story.

At this moment Sharon is looking at her husband's body, and she's wondering how she can tell him that she's been having sexual fantasies all day. She would like to be able to tell him what she has been thinking about. She would like to be able to describe to him the way she feels about his body, his lips, his hands, and his penis. She would like to be able to tell him how she wants to make love right now, and how turned on she's feeling. But she can't.

So instead, Sharon will do what she always does when she wants sex. She'll walk up to Richard and kiss him and move her hands up and down his back and hope he gets the message. Sometimes he does and sometimes he doesn't. But even when Richard does respond, Sharon knows there will be other messages he will never get, and that the sex won't be anything like what she dreams about. She knows that neither she nor her husband will be able to fully communicate what they feel or what they want.

Sharon knows that Richard is no better at talking about sex than she is. When he's feeling sexual, what he usually does is turn off the television, take her hand, and lead her to the bedroom. It's very sweet, but as seductive techniques go, it's not exactly a mood setter. Once inside the bedroom, it's pretty much the same story. Richard is a skilled lover, but aside from an occasional moan, he's a silent partner after the lights go out.

Sharon wishes it were different. Why can't Richard be more verbal about sex? For that matter, why can't she? Sharon wishes she could tell Richard how badly she wants oral sex. She wishes she could cry out during her climax and that he would too. She wishes she could ask him to make love to her in the shower and then on the floor in front of the fireplace; to pour champagne over her and then lick it all off, paying particular attention to her toes. Lady Chatterly covered her lover's penis with flowers and they talked about what it looked like. Why is it that Sharon and her husband could never talk like that? And what is

Richard *really* feeling behind that quiet façade?

Sharon is concerned that she and Richard will go through life never experiencing any of this, and that their sex life will always be silent. She fears that Richard will never tell her what he truly wants or how he's really feeling, that she will never tell him what she wants and what she's feeling, and that they will both always be a little disappointed. Maybe this is the way most people live, but Sharon has always hoped it would be different for her.

The one thing Sharon does not yet know is that it *can* be different. Sharon may feel resigned right now, but the fact is that, if she chooses, she could easily break the sounds of silence—*forever*. Sound impossible? It's not. It's simple. It's also exciting. It's even fun. And believe it or not, it's just a few breaths away. . . .

When Naughty Is Nice

ANY woman who is lucky enough to know will tell you: Nothing is more exciting than talking sexy to the man you love and having him talk sexy to you. Nothing. The right words at the right time can start a fire burning inside of you that feels like it will never go out. It can make you breathless. Insatiable. Unstoppable. And it can do the same thing for your man.

Maybe you already know exactly what I'm talking about. Perhaps you have been with a man who knows how to talk sexy to a woman, and who loves it when she responds in kind (if you're *really* lucky, you may be with him right now). Perhaps you've heard friends tell stories about the

sexiest lovers they've ever had, and the way these men talked to women. Maybe you've found yourself smoldering over the daring use of language in a steamy film or novel. Or maybe you just have a good imagination. But if you don't know what I'm talking about, you're about to find out. And believe me when I tell you that your sex life will never be the same.

How Do I Know So Much About Talking Sexy?

I am a sex therapist, and I have been in practice for five years. For twelve years prior to that I worked with both couples and individuals as a surrogate sexual partner in a well-known California clinic. I have also taught classes in human sexuality at various colleges in southern California. I have talked to thousands of people about their sex lives, and worked personally with hundreds and hundreds. Human sexuality is both my vocation and my passion. And if there is one thing I have seen make more of a difference in the sex lives of more people, it is the language of love.

Talking sexy changes the way you experience sex. It turbo-charges lovemaking, connecting you to your deepest desires, your most profound passions, and your greatest sexual power. It's hot, it's exciting, and it's surprising. It's loving and it's fun. It heightens anticipation, magnifies erotic sensation, deepens human connection, stimulates the imagination, and intensifies orgasm. It's the

ultimate turn-on. And it's completely fat free! I don't think you could ask for much more.

Sexual Liberation, or Communication Breakdown?

As you can probably tell, I have a tough time hiding my enthusiasm about the many benefits of talking sexy. But before we take another step forward, I think we need to take one back and face a few facts.

The sexual revolution may have changed a lot of things, but it certainly hasn't changed the way most of us—both men *and* women—talk to our partners in bed. Sure, some of our behavior has been liberated. But when it comes to the language of love . . . forget it! When most people have sex, they still act like they're doing it in the library! We may talk a good game in the powder room and the locker room, but not in the bedroom, where it counts the most. There it's a very different story, where silence is still golden and even the most incessant talker is likely to clam up when the lights go down.

Though a lot of us wish it were different, the vast majority of us are still trying to communicate our deepest sexual needs and sexual feelings through a complex combination of grunts, gestures, mutterings, and breathing cues. This is just too hard. It leaves a partner wondering: Is she excited or is she in pain? Is he into this or is he asleep? You know the result: confusion, misunderstanding, disappointment, and most of all, frustration.

Imagine if we had to communicate all of our important human needs through the language we use in the bedroom. We'd all still be in caves, huddled around a fire, chomping on zebra meat. Human beings, unlike other creatures on this planet, have a great gift: the gift of language. But when we get into bed, it suddenly disappears. We're embarrassed by, maybe even terrified of, our own impulses, our own sexuality, our own humanness.

What's amazing to me is the absolute power of the taboo of silence. The same men and women I see fearlessly speaking their minds at high-powered corporate meetings, in high-pressure academic environments, in high-price supermarkets, and on high-speed freeways have so little to say when they're wearing nothing but a bedsheet.

What Are *You* Waiting For?

What about you? What's your story? Perhaps to the outside world, you're a politically correct career woman, a dressed-for-success sophisticate, or a mild-mannered mother of two. But that's not at all how you feel *inside*, is it?. No, no, no. Inside you feel sexy, incredibly sexy. You feel hot and wild, maybe even dirty and outrageous. A vixen. A smoldering volcano waiting to erupt.

If you had the courage to fully exercise your constitutional right to freedom of speech, what do you imagine your personal style might be? Would you be soft and loving? A little bit raunchy? Funny? Wicked? Ribald? Direct? Obscene? Off-the-wall?

If you could start talking sexy to your partner tonight, what would you want to say? And how would you want to say it? Sometimes, the words "I love you" can be very sexy. Most of us don't say those three words enough. But there's also so much more. Simple sentences such as, "I love to look at your body," "I want you," "I need you," or "I want to make love to you" can dramatically change the course of an evening, and sometimes, the course of an entire relationship. You've probably thought about saying things like this to your partner many times, but could you imagine actually doing it? Do you wish you could turn to your partner and say, "I need to feel you inside of me," "You make me so hot," "I love to look at your beautiful penis," "I want to feel your tongue between my thighs," or "Take me"? Do you wish you could read him sexy poetry or passages from an erotic novel? Do you wish you could whisper dirty words into his ear, or cry out during orgasm? It's pretty exciting just thinking about it, isn't it?

So what's stopping you? Actually, that's not really a fair question because I *know* what's been stopping you. It's the same thing that stops so many women just like you. It's the same thing that stopped me for so many years of my adult life. Let's face it, it's one thing to *want* to talk sexy to your partner, but quite another thing to actually do it.

Talking sexy may be hot, hot, hot, but that doesn't mean it's easy. It has been my experience, both professional and personal, that most people are *terrified* of uttering a single sexy word. Most

of us wish we had the courage to ask for what we really want and to say how we really feel, but even if we open our mouths to try, the only thing that comes out is air. The thoughts may cross our minds over and over again, but the words never cross our lips.

While every woman has a slightly different reason for *not* talking sexy, the result is always the same: silence. Well, I've got some good news. It doesn't have to be this way—not any more.

Any Woman Can Learn to Talk Sexy

This book is for any woman who is tired of being afraid and wishes it were different. If you are frustrated by the sounds of silence, and ready to break that sound barrier once and for all, I'm here to help.

I want to teach you how to start talking in bed—*really* talking. We have to start saying "those words" we can't say, asking for "those things" we never ask for. We have to start letting our partners know what we need and how we are feeling. We have to talk about every beautiful part of the female body—our skin, our breasts, our stomach, our buttocks, our thighs, our vagina, our pubic hair, our clitoris. And we have to talk about every beautiful part of the male body, including his face, his neck, his arms, his legs, his penis, his testicles, his buttocks, his thighs, his chest. We have to be explicit and we have to be direct. And so do our partners.

Any woman can learn to talk sexy, and in this

book I'm going to show you how. Whether you've never uttered a single sexy word in your life, or you're just concerned that you're not living up to your full sexual potential as a woman, the exercises in this book will help bring out the best in you and bring out the beast in you. You're also going to learn how to get your man talking right along with you. It's all easier than you think, and the payoffs are far greater than you probably imagine.

There's Nothing to Fear but the Excitement (And There's Nothing to Lose but Some Sleep)

There is one thing I need to make clear from the very beginning. Talking sexy does *not* mean being degrading, disgusting, or demeaning. It does *not* mean being cheap or callous. It means being provocative, enticing, electrifying, and seductive. It means being more real and more clear. It means not being afraid to ask for what you want, to say how you feel, and to encourage your partner to do the same. It means having a lot more fun in bed, and generating a lot more heat.

I'm not a neurophysiologist or biochemist, and that means I can't tell you exactly *why* talking sexy is so unbelievably electrifying and *why* talking sexy will make you and your partner feel so damn sexy. All I can tell you is that it is, and it will. Right now I'm asking you to take my word for it, but you won't have to do that for long. The

moment those first few words pass through your lips and into your partner's ears you're both going to know you've struck gold.

Are you a little nervous? Don't be. I'm not going to put words in your mouth, I'm going to help you get them out. I'm a professional sex therapist. I've taught hundreds of people how to talk with their partners about sex; I've taught them how to be more open, more direct, more honest, and a lot more sexy. I know I can teach you too.

Talking Sexy Should Bring a Couple Together

I'm hoping that my little pep talk has already started to warm your cold feet and get you excited about what lies ahead. You may already be discovering what a turn-on it is to just *think* about talking sexy to your partner. But before I cut to the chase and introduce the first exercise in this book, we need to spend just a few more very important moments talking candidly about your relationship.

Sex doesn't happen in a vacuum. Sex happens between two people; hopefully, two people who love each other. The goal of talking sexy is to bring a couple closer together. I'm assuming that you would not be reading this book right now if this was not what you were hoping for. I want to help you change your relationship for the better, not to create problems. Your needs are important, but the needs of the couple come first. That's why

it's important to know, before you begin, that you have your partner's understanding and that you have his support.

In my work as a sex therapist, I am always teaching my clients new skills. Some of these skills are technical, some of them are creative, and many are communication oriented. But whatever it is that you are learning—whether you're learning a new way to touch, a new way to move, a new way to speak, or a new way to feel—you are learning something very powerful. This is particularly true when it comes to learning how to talk sexy. This power should not be taken lightly.

It may be hard to imagine right now, but talking sexy is going to change the way you make love. The intensity of both your responses and your partner's responses to this new style of communication can come as quite a shock to lovers who have always communicated using Morse code. You are going to have a very new and different experience of yourself and of your partner, and your partner is going to have a very new and different experience of himself and of you. That's a lot to reckon with, and it is *crucial* that your partner is every bit as prepared for this as you are.

In the next chapter, I'm going to give you some important guidelines that will help both you *and* your partner get ready for the many changes that are waiting just around the corner. I know that you're anxious to start talking sexy; I'm anxious to get you started. But before doing *any* of the exercises in this book, take the time to read

through Chapter 2 carefully, and please take my advice to heart.

At the end of this book, I have also included a special section just for men (see Appendix: For Men Only). My main purpose for including this material is to give encouragement, support, under-standing, and guidance to any man who is feeling the least bit unsure, skeptical, anxious, or tenta-tive. Yet at the same time, I feel that *every* man, no matter how comfortable he is with the concept of talking sexy, would benefit from reviewing this section.

Talking to Your Partner about Talking Sexy

I'M not a big believer in surprises when it comes to sex. The thought of springing something new on your partner may seem very exciting at times, but it is my experience that surprises like this often backfire. This is why I always insist that my clients talk to their partners *before* they try to introduce important changes into their lovemaking. Right now, I'm going to ask the same thing of you.

Your Partner Needs to Know That You Want to Talk Sexy

When it comes to issues about our sexuality, we are all fragile creatures. Anything too new or too different—like having a partner suddenly start talking sexy for the first time—can feel scary, threatening, intimidating, or confusing to someone who has not been adequately prepared for such change. Something like this could make your partner feel very insecure or very left out. It could even make him suspicious or angry.

I don't want any of that to happen. I want your partner to be excited, open, ready, and receptive. I want talking sexy to enhance, enrich, and deepen your relationship, not sabotage it. That's why, before you start talking sexy to the man you love, you need to sit down and talk straight.

You Might Want to "Just Do It!," But I Think That's a Mistake

I know it isn't easy for most women to talk to their partners about their sexual relationship. And as far as talking sexy is concerned, many women feel far more comfortable doing it than *talking* about doing it. You need to know that it is perfectly natural to have any number of concerns, such as, "What will he think about me?" "How will this make him feel?" "Will he be pleasantly surprised or shocked and turned off?" The truth is that every man is different, and you

simply can't know the answers to these questions until the two of you discuss it.

If you *don't* have this conversation, however, and your partner is not adequately prepared for the changes that will soon be taking place in your vocabulary and your behavior, he is far more likely to wonder, "Where did she hear that?" or "Where did she learn that?" These are the kinds of things you *don't* want him worrying about. Even if your partner has been bugging you for years to spice up your language—even if he's the one who's been doing all the lobbying for eroticizing your relationship—I don't recommend surprising him with a "new, sexier you." He needs to be prepared.

But How Do You Start?

When you talk to your partner about your desire to talk sexy, it is very important that your conversation is given ample time, and that it takes place in supportive surroundings. You don't want to have this conversation as he's running out the door, for example, or while you're stuck in traffic and talking to him on your car phone. It's perfectly fine to talk in bed, as long as sex is not on the agenda for that evening; but you don't want to have this conversation just before, while, or right after making love.

Sometimes, an opportunity to talk to your partner will present itself naturally. You might be watching a film, for example, in which one of the characters uses sexy language. Use this as a

springboard to reveal your interest, starting with a comment such as, "I loved the way that woman was talking to her partner when she wanted him." But many times, an opportunity must be created. And that can be scary.

Telling the man you love about your desire to talk sexy is a wonderful opportunity to express your love and your caring, but that doesn't make it easy. If you're feeling awkward or uncomfortable having this conversation, the very first thing you need to do is let your partner know how difficult it is for you to talk about your sexual relationship, and how worried you are about how he will respond. It's a great way to break the ice, and he's certain to appreciate your honesty and your vulnerability.

Let Him Know You Love Him, Let Him Know You Want Him

After you've broken the ice, the very next thing you need to do is tell your partner how much you love him and how important it is for you to be able to express your love more fully. Once you have made this point clear, the stage is set to tell your partner the wonderful news: The woman he loves wants to learn how to talk sexy.

Tell him what talking sexy means to you, and why you're so excited about doing it. Tell him what you think it will do for you as a woman, for him as a man, and for the relationship you share. Most important, make sure to tell him that you are doing this for *both of you*, and that you

would never want to change anything in your relationship without his support.

If you suddenly find yourself at a loss for words, you may want to take out this book and show it to him; the conversation will certainly evolve from there. The important thing is that you are completely honest, and that you don't try to withhold anything. The more your partner understands right now, the better it is for both of you.

Be Sure to Talk About *His* Needs

While it is very important that you talk about *your* needs, it is equally important to talk about *his* needs. How does he feel about this? Has he ever had similar desires? Does anything make him uncomfortable? Is there anything he fears? Pay close attention to his answers, and don't assume anything. You may be surprised to discover that you know far less about your partner than you think.

Talking sexy may very well be the answer to your partner's prayers—a dream come true. If so, you now know you've got the green light to proceed. But if he seems uncomfortable, disinterested, or totally turned off, you need to respect that. Talking sexy is not for everybody. And while I feel sorry for those men and women who can not incorporate exciting language into their lovemaking, I also realize that some individuals have very good reasons to *not* incorporate it. Being a good lover means, first and foremost, always

being sensitive to the needs of your partner. The last thing you want is to be doing something that he simply doesn't want, or worse, doesn't like. If you are just taking care of yourself, oblivious to the needs of the man you love, you're not making love, you're making a mistake.

Never Let Desire Sound Like Demand

If there is one thing that stops a man from getting excited about talking sexy it is the fear that sexy language will translate into sexual demands. In the heat of making love, as your new style of communication reaches the boiling point, you may find yourself thinking about, wishing for, and asking for all kinds of things that may never have even occurred to you before. This could bring both of you to new heights of passion. But if your partner interprets what you are saying as nonnegotiable demands, the pressure could shut him down.

It is important to make it clear from the very beginning that you are genuinely concerned about how your new vocabulary will be heard, and that *nothing* you say ever needs to be taken literally. You will be expressing wishes, desires, and fan- tasies. Much of this needs to remain in the realm of fantasy, particularly since, as you will soon dis- cover, the biggest turn-on is often in the *saying*, not in the doing. Whatever it is that you say, your partner needs to understand and believe that you are not *demanding* anything, nor are you *expect- ing* anything other than an opportunity to speak

your mind, to play with possibility, to free your imagination, and to free your feelings. He doesn't need to *do* anything but let you talk.

If, for example, you say to your partner, "I want to make love till the sun comes up," he has no reason to take this as a statement of fact. He needs to understand that you are merely expressing your mood; you are *not* issuing your requirements. In actuality, you may have absolutely no desire to stay up all night. You may have no desire to stay up past ten o'clock. You might not even want to make love at all—maybe you have company coming any minute, maybe the kids are still awake, or maybe you're standing in the middle of Central Park. You are just letting him know that you are feeling close to him and feeling desirous of him.

If your partner is interested in responding to some of the things you say, that's wonderful. But you need to make it very clear to him that if he isn't interested, that's fine too. Whether it's something you ask for, beg for, or cry out for, he is under no obligation to do anything. You will always love him just as much, and you will always want him just as much. You just need to talk sexy.

Keep His Sensitive Spots in Mind

While I encourage you to explore the deepest recesses of your sexuality, I must also ask you always to be sensitive to your partner's capabilities and his limitations. Don't ask for the moon if

you know that he can only deliver a few shining stars. If, for example, your partner tends to ejaculate fairly quickly during intercourse, you don't want to ask for "an hour of great screwing." If he is concerned about his erections, you don't want to tell him how badly you "need it big and hard." I understand that there are some things about your partner you simply cannot know until you ask him. When that is the case, try to be excessively gentle and caring in your presentation. Remember that you always want talking sexy to be a source of excitement and erotic connection, not a source of unnecessary friction.

Did Your Partner Give You This Book?

If your partner gave you this book then you already know how he feels about hearing you talk sexy. But that still doesn't mean you should just turn to Exercise 1 and jump right in. You need to ask a few questions first.

How carefully did he look at the book before he handed it over to you? Does he know what it is he is asking for? What, exactly, are his expectations? Is he sure *he* is ready? Is he prepared to be totally accepting of the results? You need to be sure right now that your partner's attitude is realistic and reasonable.

And how do *you* feel about this book? Does the idea of talking sexy shock you? Scare you? Turn you on? Turn you off? Turn you upside down? Before you do anything, I think it's very important to get clear within *yourself* whether or

not this is something you want. If it isn't, *stop right here.* I don't believe in trying to please a man if it does not please you too. As I've said already, talking sexy is not for everyone. If you know it's not for you, you should not let any-one—not even the man you love—pressure you into trying.

Even if the thought of talking sexy excites you, you need to make it very clear to your part-ner that you will proceed at your own pace, in your own way. And if you feel pressured at any time to "deliver the goods," you need to commu-nicate this to him immediately.

If it sounds like I'm asking a lot, I am. Talking sexy can trigger many sensitive issues for a cou-ple, and I want to be absolutely sure that, before we begin, these issues are attended to as carefully and as thoroughly as possible. Sexual pressure, miscommunication, and missed communications (conversations that should have taken place, but didn't) create sexual tensions of the most unpleas-ant kind. Relationships, as you well know, are hard work under the absolute best of circum-stances. Unnecessary sexual tension is the kind of conflict that every couple could live very happily ever after without.

Get Ready, Get Set . . .

You're almost ready to begin. Starting in Chapter 4, you will find fifty-one easy-to-follow exercises that have been designed and organized with one goal in mind: To teach *any* woman, even the shyest rose, how to become completely comfortable talking very, very sexy.

Most of the exercises in chapters 4 through 11 are what I call "solo" exercises for women, and are clearly labeled as such. Solo exercises are exercises that I would like you to do *alone* (that is, without your partner), in the privacy of your own home. In some of the exercises you will just be writing, in others you will be whispering, speaking out, or even shouting; in a few exercises

I will be asking you to do nothing but use your imagination, while in others I will be asking you to use your vocal cords to their fullest capacity.

To do these solo exercises, you need to feel completely safe. This means that *no one should be able to hear you*—not your partner, not your children, not your neighbors—no one. If you have to lock yourself in the basement, or practice in the shower, that's okay. The important thing is that you are absolutely certain that no one but you can hear.

Later in the book, you will find a number of partner exercises, labeled "With a Partner." These exercises have been designed for a couple to practice together, if your partner is so inclined. *It is important that you and your partner have complete privacy* while doing these exercises. You need to be out of earshot of children, relatives, neighbors, and law enforcement officials. If there is no private, reasonably soundproof place in your home, send the kids to their grandparents' or to another trusted relative's house. Better still, get a sitter for the kids and go to a motel—preferably one that has solid, well-insulated walls between rooms.

You'll Need a Notebook . . .

As you begin to look through the exercises, you will notice that periodically I ask you to write things down. Sometimes I ask for specific words, phrases, or sentences. Other times I will ask for thoughts, associations, dreams, fantasies, stories, or

recollections. I am doing this because, as you will soon discover, writing is a powerful tool for freeing both your imagination and your tongue. Please believe me when I tell you that the writing assignments in this book are every bit as important as the speaking assignments. Don't give them short shrift.

Buy a small notebook or journal and use it exclusively for the exercises in this book (don't clutter it up with grocery lists, phone numbers, tax records, etc.). Think of this as a special record of the exciting journey you are about to take to your own wild side.

Keep This Material Private!

This is very important. You are the *only* person who should have access to your writing. This material is deeply personal, and belongs only to you. I realize that there may be a number of occasions where you choose to share some of this writing with your partner. I don't want to discourage that. Under the right circumstances, this can be terribly exciting for both of you. But the decision to share this material must be yours and yours alone to make. To learn to talk sexy, you need to feel totally safe.

To insure this, it is crucial that you have complete control over any access to your notebook. If you fear that your partner, your children, your roommate, other members of your family, or *anyone* other than you could read this material against your wishes, you will not feel safe, and you will not be able to complete the exercises in

the style in which they were designed. If you cannot be absolutely certain that your notebook can be kept totally private, I discourage you from keeping *any* written records of these exercises. If you still wish to do the written portions of any exercises, I recommend using individual sheets of paper that you can dispose of at the end of each exercise. This may slow you down a bit, since some of the later exercises utilize material from previous exercises and you may have to rewrite your earlier responses. But privacy is more important than anything else. I must also ask you to please be thorough with your paper disposal process. A paper shredder may be a bit much, but don't leave a semicrumpled ball of eroticisms sitting at the top of the wastebasket.

Use My "Sample Pages" as a Guide

As you flip through the exercises, you will also notice that some of the pages in this book have been set up to look like workbook pages. This has been done for you to use as a guide.

Don't write directly on these pages. It is much easier to work with a notebook, and you're going to need the extra space. Even more important, working with a notebook leaves you free to share *this* book with your partner without having to worry about whether or not he sees your private notes. Right now, you may feel that you want to share *everything* with your partner, but that feeling may change as you begin exploring very intimate and personal material.

As you begin each exercise, copy the relevant Sample Page(s) into your private notebook. Then, follow the directions from the exercise as they apply. You will also notice some directions printed on each Sample Page.

Start from the Very Beginning . . .

The exercises in this book are presented in a very specific order, starting with simple icebreakers, and slowly building up to serious ice-melters. Please try to do the exercises in the order in which they've been presented. Otherwise, you might find that you've taken on a little too much too soon. I encourage you to repeat exercises numerous times, getting very comfortable with what you've learned at each step before moving on to the next one. If you need to backtrack, that's okay too.

The easiest way to do these exercises is to read through each one carefully before you begin. Reread it if necessary. Then start the exercise as instructed.

If you are working on a partner exercise, both of you should read through the exercise before you begin. Then discuss the exercise once you have both read it. It is important that both partners understand their individual roles in each exercise. If either of you has any questions, doubts, or concerns, it is important to flush them out *before* you get started. Keep that line of communication open and clear. The more you talk now, the more you'll want to talk later.

And Don't Rush . . .

By the time you have completed all of the exer-
cises in this book you will have all of the tools
you need to talk sexy for a lifetime. But even the
exercise program itself has been designed to add
spice to your lovemaking for many weeks or
months. So take your time, and enjoy it.

I discourage anyone from trying to complete
all fifty-one exercises over a long weekend. It isn't
necessary, and it won't be as exciting or as help-
ful. There is absolutely no reason to rush. You
don't have to complete half a dozen preliminary
exercises before you get to the good stuff; every
exercise is exciting and every exercise has its own
erotic payoff. Pace yourself comfortably and try
to savor each one. You will quickly discover that
the anticipation of adding a few new exercises
every week to your erotic repertoire will add an
exquisite element of sexual tension to your every-
day life.

Giving Yourself Permission

W HEN it comes to the subject of talking sexy, I could speak volumes. But I've talked enough. It's time for *you* to start talking. It's time to start learning firsthand just how nice it can feel to be a little bit naughty. It's time to get down and get sexy. Are you with me? Have you simmered in silence long enough? Are you ready to feel the burn? Good. Then let's get started. Trust me, it won't be long now before you understand why I always say: You haven't really had sex until you've had sex while talking sexy.

You will notice that this chapter contains only one exercise. This solo exercise is very simple, probably the simplest in the entire book. But

don't let that fool you. I honestly believe that Exercise 1 is the most important exercise you will learn. Why? Because it is going to help you give yourself permission to start talking sexy.

Talking Sexy Starts by Saying "Yes"

What a difference a word makes, especially if that word is "yes." In this first exercise I'm going to ask you to say only one word—one very sexy, exciting, provocative word—and that word is "yes." Okay, so maybe it doesn't sound that sexy right now. But believe me, it will when you start saying it, because "yes" means "I give myself permission."

"Yes" means giving yourself permission to be more expressive with your partner before, during, and after making love. "Yes" means giving yourself permission to experience the deepest recesses of your erotic self, to break taboos, to reveal a sensual side of yourself you have always kept secret. "Yes" means giving yourself permission to live a fuller, more gratifying, more electrifying, and more complete life with the man you love. Sound simple? It is. But it's also true.

It is my conviction that the single greatest obstacle to talking sexy is giving yourself permission. Even if the words, the fantasies, and the desire are all there, there's this awful policeman who is also there, alive inside your head, stopping you from letting go. You know the voice—cold, judgmental, maybe even merciless. Now there may have been a time in your life, when you were

much younger, that this policeman protected you, stopping you from being careless or out of control. But you're a grown woman now, and all this policeman is doing today is keeping your lips sealed tight and taking the joy out of your sex life.

Enough is enough. Life's too short, and that list of things you're missing out on is getting too long. It's time to tell that officer that he's no longer welcome. It's time to pack his bags, get him his coat, and buy him a one-way bus ticket out of town. It may take some work. But one little word is going to get you started.

Exercise 1 Yes!!!

(SOLO)

Go into your bedroom, bathroom, home office, or other private, quiet, soundproof room and lock the door behind you. Take out your notebook and open it to the first page. Enter today's date. Write down everything you see on Sample Page 1a, just as it appears in this book. Take your time, savoring each sentence as you write it.

Sample Page 1a

(COPY)

Yes!

YES! I want to talk sexy!

YES, I need to talk sexy!

YES, I'm ready to talk sexy!

YES, I'm going to talk sexy!

YES, YES, YES, YES, YES!!!

Good. Now turn to the second page in your notebook and write down all of the sentences on Sample Page 1b, exactly as they appear in this book.

Sample Page 1b

(COPY)

Yes, I want to talk sexy to my partner before, during, and after we make love!

Yes, I want to discover the deepest recesses of my erotic self!

Yes, I want to break old taboos!

Yes, I want to show my partner the deeply sensual side of me I have always kept hidden!

Yes, I want to live a fuller, more gratifying, more electrifying, more complete life with the man I love!

YES, YES, YES, YES, YES!

Great. Are you starting to tingle? I'm not surprised. Now close your notebook. You're ready to start talking.

At this point, I'd like you to stand or sit in front of a mirror. A full-length mirror is ideal, but a smaller mirror is adequate as long as you can at least see your entire face. Too small a mirror, such as a compact mirror, will affect the impact of the exercise.

Let yourself relax. Breathe deeply. Take a good look at yourself in the mirror. Look at what a sensual, vibrant, exciting woman you are.

Now open your mouth slowly and mouth the word "yes." Don't speak it, just mouth it. Now mouth it again. And again. And again. And again.

Continue to look at yourself in the mirror. Now, in the softest whisper, say the word "yes." Whisper it again. And again. And again. And again.

Now say it a little louder, say "yes." Say it again. And again. And again. And again.

Now speak it fully—"Yes." Speak it fully again. And again. And again. And again.

Keep looking at yourself in the mirror. Now raise your voice and announce it: "Yes." Announce it again. And again. And again. And again.

Now I want you to shout—"*Yes!*" Shout it again. And again! And again. And again. Shout it repeatedly: *"Yes."*

Now take a few deep breaths and relax. Open your notebook again and, on a new page, write down any erotic thoughts or feelings you're having right now (see Sample Page 1c).

Sample Page 1c

(COPY AND COMPLETE)
Erotic thoughts or feelings I'm having right now:

That concludes our first exercise. Congratulations. You did it. There's no stopping you now. You're on your way to talking sexier than you could have ever dreamed possible to the one you love.

I Wish, I Want

Now that you've given yourself permission to talk sexy, it's time to start asking yourself some intriguing questions. What is missing from your love life right now? What do you really want? What do you really need? What secrets do you need to share? Do you have any fantasies that are aching to become realities? If you had one wish, what would it be? Your answers to these questions might surprise you. You may not even have any good answers right now. Most people are so scared of rocking the boat they never let themselves feel their deepest desires. But you have to know what you want before you start asking for it.

The secret to freeing your tongue and freeing your body lies in freeing your imagination. You've probably heard this before, but I think you need

to hear it again: Sexual excitement does not begin in the bedroom, it begins in the mind. Free your mind, and the sky is truly the limit.

Just How "Dirty" Is Your Mind?

You are about to discover what an incredible turn-on it is to just *think* about talking sexy. In the next set of exercises, you are going to get your first chance to let your imagination run totally wild. Believe me, it won't be long before you start running after it. These exercises are creative, highly stimulating visualization exercises designed to help you gently confront your personal "wall of resistance" and to begin climbing that wall. These exercises are all nonverbal. You're not going to say a word. You don't have to. So relax, take out your notebook, and get to work.

Exercise 2: Imagine

(SOLO)

Go into your bedroom, bathroom, home office, or other private, quiet, soundproof room and lock the door behind you.

Sit in a comfortable chair and let yourself relax. Breathe deeply. Now close your eyes.

I want you to imagine what the rest of your life is going to be like once you start talking sexy to the man you love. Imagine that you have absolutely no fear, that you can completely let go. How will that change the way you make love?

Imagine that starting right now, you had the courage and the vocabulary to start talking sexy

to your partner. What would you say? When would you say it? How would you say it? Would you call him on the telephone to tell him your fantasies, or would you wait till the two of you are together? Would you whisper something in his ear when you're together on the couch, or would you wait until you're in the bedroom? Would you wait until you're undressed or would you tell him how to undress you? How would you ask him to touch you? What would you tell him you really needed? What would you tell him about his body?

Now imagine how that would feel. As you start to make love, what might you say? Would you guide him? Would you show him how to touch you? Would you tell him how that feels? Would you tell him how hot you are? Would you whisper all kinds of dirty words in his ear? Would you moan? Would you cry out? What would you sound like? What would you look like?

And how would he respond? What would he say to you? What would he do? How would his body respond to all of the things you're saying, and to all of the things he is saying? And how would your body respond?

Imagine. Just imagine. Let yourself go. You have nothing to be afraid of. There's no one here but you, and it's only an exercise in fantasy.

Give yourself at least fifteen minutes to let your mind wander. If you're drawing a blank right now, or feeling rather unimaginative, don't be concerned. The remaining exercises in this book are bound to fill your mind with extraordinary ideas.

When you are ready to stop, open your notebook and record what this experience was like for you. Use the questions on Sample Page 2 as a guide.

Sample Page 2

(COPY AND COMPLETE)

What was this exercise like for you?

What did you imagine?

What was the most memorable part of this exercise?

What, if anything, made you uncomfortable?

What would you like to work on the most?

∼

Don't Be Shy. . .

"Imagine" can be a very exciting exercise. Perhaps you're already feeling some of that excitement. If this exercise turns you on, you're not alone. Many of my clients have told me that they can't complete this exercise without masturbating. Perhaps you're feeling the same way right now. Perhaps you've already attended to that need. Good for you. This is a very normal reaction. There is no reason to be embarrassed by these feelings and there is no reason to hold back. Half the fun of these exercises is the turn-on. So why turn off?

Some of my clients have actually reported reaching orgasm during this exercise without masturbating—without lifting a finger, so to speak (or anything that is battery-powered). Did the same thing happen to you? Once again, there is no reason to be embarrassed or concerned. These are all healthy signs that the exercises are already opening you up to experience a more vibrant, sexual, complete you.

When in Doubt, Get It in Writing

When you are ready to move on to the next exercise, turn to a fresh page in your notebook. It's time to start getting more concrete and more specific. In Exercise 2 I asked you to simply take a stroll through your own imagination. In Exercise 3 you're going to wander through your imagination again, but this time, you're going to record the experience in much greater detail.

Exercise 3 gives a whole new meaning to the phrase "get it in writing." Getting what you want starts by getting it down on paper. The physical act of actually writing down, in as much detail as possible, your wants, needs, hopes, desires, and fantasies is a powerful way of not only stimulating the imagination, but of bringing that imagination to life. It helps you face who you are and get comfortable with who you are, while making it far more difficult to deny those parts of yourself that are tired of being denied.

With this in mind, take a look at Exercise 3.

Exercise 3: Wish List

(SOLO)

Copy Question 1, exactly as it appears on Sample Page 3, into your notebook. Now answer this question, in writing, being as elaborate and comprehensive as possible. Use as many pages as you need.

When you have finished answering Question 1, leave a lot of additional blank space for more writing. You'll need this space when you return to this question in Exercise 4. If it takes you five lines to answer this question, leave at least five more lines blank; if your answer fills an entire page, leave at least one full page blank, etc.

Copy Question 2 into your notebook. Now answer this question, being as elaborate and comprehensive as possible. Once again, leave ample blank space in your notebook at the end of your answer. Proceed in this fashion until you have answered all of the questions on Sample Page 3.

Take as many days as you need to complete this exercise. You don't *have* to do them in numerical order, and you don't need to rush. Think about each question carefully. Do some brainstorming. Revise your answers as often as you need to. Remember that the material you generate now will provide the foundation for many future exercises.

Sample Page 3

(COPY AND COMPLETE)

Question 1: What made you want to read this book?

Question 2: What does talking sexy mean to you?

Question 3: What sexy words and phrases do you wish you could say out loud?

Question 4: How would you say these words and phrases? Would you be forceful, playful, gentle, pleading, demanding, screaming? When would you say them? Over the phone, when you're cuddling, during a romantic moment, in the shower or tub, before bed, before you undress, while you undress, in bed,

during foreplay, during oral sex, during inter-course?

Question 5: What sexy words and phrases do you wish your partner could say to you out loud?

Question 6: When would you want your partner to say these words and phrases to you? Over the phone, when you're cuddling, during a romantic moment, in the shower or tub, before you undress, while you undress, in bed, during foreplay, during oral sex, during intercourse? How would you want him to say them? Forcefully, playfully, gently, pleading, demanding, screaming?

Question 7: If you had the courage to ask your partner for *anything* in bed, what would you ask for? How would you ask—what words would you use?

Question 8: In addition to talking sexy, what sexual behaviors, positions, techniques, games, or clothing do you wish you could experiment with?

Question 9: What sexual fantasies do you wish you could share with your partner? Which, if any, of these fantasies would you want to actually experience for real?

Question 10: When you think about your partner's body, what turns you on? Describe it in detail.

Question 11: When you think about your own body, what turns you on? Describe it in detail.

Question 12: What sounds do you wish you could make when you're making love? What sounds do you wish your partner would make?

Question 13: How do you need to be touched? If you had the courage to speak up, how would you tell your partner to touch you?

Question 14: Imagine you are making love right now and you are whispering into your partner's ear. What would you be saying?

Question 15: Imagine you are making love right now and your partner is whispering into your ear. What do you wish he was saying?

Question 16: If you were so uninhibited that you could cry out during lovemaking, what would you cry out? And when would you do it? During oral sex? Upon penetration? During intercourse (which positions)? During orgasm? During your partner's orgasm? All of the above?

~

After you have completed all sixteen questions in Exercise 3, put your notebook away. Try to take your mind off sex for a while—it may be your last chance! Clean out your closets, plant an herb garden, or bathe the dog; take long walks, ride your bicycle to the beach, or go for a

scenic drive. Then, after at least one or two days have passed, begin Exercise 4. And please note: If you are disposing of all written material after each writing session, you may prefer to proceed immediately to Exercise 4 to avoid extensive rewriting.

Exercise 4: Read My Mind

(SOLO)

Take out your notebook and open to your completed Exercise 3. (If you had to dispose of your notes, start by repeating Exercise 3 on a fresh sheet of paper.) Look at Question 1 and slowly read through your answer. You don't have to read it aloud right now—we'll be trying that later on. But it is important to get the feeling that you are reading to yourself in much the same way you would read aloud, slowly and attentively. What does it feel like to read over what you have written? Add to your answer if there is something you left out, or if you have any new thoughts.

Now look at Question 2 and read through your answer in the same careful fashion. Once again, feel free to expand upon your answer at this time.

Proceed in this way through the remaining questions.

∽

Exercise 4 may seem rather simplistic, but don't let that fool you. If you want to change the way you talk to the man you love, it is very

important that you get to know all of the facets of your erotic self. It is also crucial that you learn to accept these many facets, and, ultimately, to embrace them and celebrate them as a vital and invaluable part of you. By reading through this material over and over again, you are beginning to do just that.

But that's not all. If you want to change the way you talk to the man you love, you need to start changing the way you talk to yourself. You need to get used to chatting with yourself about sex in a more candid, graphic, and gutsy fashion. You don't need to be chatting aloud, at least not yet. But you need to be chatting. The more comfortable you get with your own sexy inner dialogue now, the easier it will be to get those words out of your mouth later when you need them most. For these reasons, I recommend returning to Exercise 4 periodically as you proceed through the remaining chapters of this book.

From Shakespeare to Shake Your Groove Thang

The next and final exercise in this chapter is designed to help you get to know yourself even more intimately (yes, even *more* intimately). In the previous exercises, I've asked you to use your imagination as much as possible. This time, we're going to do a little borrowing from the imagination of others.

Exercise 5: Arabian Nights

(SOLO)

Did you tremble during the sex scenes in *9½ Weeks*? Have you read *Lady Chatterly's Lover* more times than you can remember? Does a Renoir nude make you want to take your clothes off too? We all have our favorite sexy stories, sexy film scenes, sexy song lyrics, sexy poetry, etc. Some of it lights our fuse, some melts our heart, and some turns our legs to Jell-O. Right now, I want to know your favorites. By answering the questions on Sample Page 5 in as much detail as possible, you're going to help yourself define and refine what it is that turns you on most. So take out your notebook and get to work.

Sample Page 5

(COPY AND COMPLETE)

Question 1: What are the sexiest films or film scenes you've ever seen?

What made these films or film scenes so sexy?

Describe the most erotic, most memorable scenes in as much detail as possible.

Question 2: What are the sexiest books you've ever read?

What made these books so sexy?

Describe the most erotic, most memorable passages in as much detail as possible. If you have these books in your possession, you may want to copy these passages into your notebook.

Question 3: Are there certain magazines that turn you on (for example, magazines with sexy stories or magazines filled with pictures of celebrity male hunks or bodybuilders)? Are there any catalogs that you find erotic to browse through (for example, lingerie catalogs)?

Describe what turns you on most about the photographs or the writing in these magazines and catalogs.

Question 4: Are there any paintings (Renoir's *Large Bathers*, for example), sculpture (Michaelangelo's *David*, for example), or other works of art that turn you on?

What is it about this art that you find so sexy?

Question 5: Is there poetry that turns you on? Are there songs that turn you on (the lyrics, the music, or both)? Make a list.

Write down your favorite sexy prose and/or song lyrics.

After you have completed all of the questions in this exercise, read through everything you have just written. Once again you need to take your time, letting the words sink in as you read to experience the depth of your full sexual self.

Getting Connected

A LOT of women who come to my office in search of advice or help tell me they wish they could talk sexy to their partners. Yet, typically, these same women are inexperienced and somewhat fearful. Many of them have never said a single sexy word in their lives. It's hard for them to imagine there will *ever* be a time when they will be able to speak an entirely new language.

I tell these women the same thing I'm going to tell you: If talking sexy is something you *really* want, if you don't pressure yourself, and if you do the exercises I give you, following the instructions as faithfully as you can, it *will* happen. It might take a few weeks, or even a few months (though it could take just a few minutes), but it will happen. But what can you do *until* it happens? What can

you do today, right now, this very moment, to get much more passion from your partner and from yourself without saying a single word? What can you do the very next time you make love that will both immediately enhance your lovemaking, and also set the stage for the eventual introduction of your new vocabulary?

Don't Say a Word to Your Partner

I have taught hundreds of women how to talk sexy. But I have never asked a woman to go home after our first session together at the clinic and try to start right in talking sexy to her partner. Never. That's just too much pressure. On the contrary, I very specifically say: Don't try to talk sexy to your partner right now—not yet—not even if you are bursting at the seams.

What I do ask each woman, however, is that the next few times she is making love to her part-ner, she complete several simple assignments. My assignments actually consist of a series of nonver-bal exercises that I will present in this chapter. Note that these exercises are not just for people who want to talk sexy. These are exercises for *anyone* who wants to feel more connected to his or her partner and intensify the experience of making love, and I assign them regularly to the vast majority of individuals and couples I work with.

I realize that these are the first exercises I am asking you to do in the presence of a partner. That could be a little scary, even though you

won't be doing *any* talking, and you won't be asking your partner to do anything at all (except, perhaps, to turn the television off). You need to know right now just how simple and nonthreatening these exercises are. In the first exercise, you will be doing nothing more than making a few basic observations during lovemaking. That's it. In the second and third exercises, you will be changing your behavior, but in very subtle ways; some of the things you will be doing are so subtle, in fact, that your partner may not even notice that you are acting any differently than you always do.

Now I realize that my descriptions do not make these three exercises sound terribly provocative, but don't let that confuse you. Follow my instructions, and these exercises are practically guaranteed to jump-start your partner and charge your battery in the process.

Exercise 6: Someone's Watching

(40 MINUTES, WITH A PARTNER)

Pretend you are a research scientist studying the sexual behavior of the human male. You have just been given a fine specimen to study: So take off your lab coat and get to work. Your job is to observe—to notice every single thing this man does while making love. How does he get ready? What signs does he give you? How does he look at you, touch you, and hold you? What does he say? How does he touch himself? Where is he the most sensitive? How does he communicate his needs? Most important: What kinds of

sounds does he make when he is making love? When does he make them? Does he say any words? What words? When? How does he say them?

Take extensive mental notes of all your observations, which you can transfer later into your notebook. Use the questions on Sample Page 6 to help you organize these observations. Like any researcher, you need to be extremely thorough. Don't try to change his behavior or your behavior at this time. Your job right now is to observe, not to interfere. To insure that your observations are scientifically valid, I recommend conducting this field study several times and comparing your results.

Sample Page 6

(COPY AND COMPLETE)

General Observations:

When your partner wants to make love, how does he let you know? What does he say? What does he do?

When your partner gets excited, how does he act? What does he say? What does he do?

While you and your partner are making love, how does he communicate with you? What does he say? What does he do?

When your partner reaches orgasm, how does he act? What does he say? What does he do?

When your partner feels you reaching orgasm, how does he act? What does he say? What does he do?

What other sexy words and phrases does your partner use before, during, or after love-making? What other sounds does he make?

What has this exercise made you notice about your partner that you never noticed before?

∽

Exercise 7: Look at You

(40 MINUTES, WITH A PARTNER)

Continue to pretend you are a research scientist. But this time you are studying the sexual behavior of the human *female*. Since the university doesn't have a lot of research money right now, they've asked you to be your own subject. Your job: Observe yourself making love.

How do you communicate with your partner? How do you let him know you want to make love? How do you know he got your message? How do you get ready? Do you talk at all? When? What do you say? How do you say it? What kinds of sounds do you make? When do you make them? How do you look at your partner? How do you touch him? How do you hold him? What about your breathing—how does it change during lovemaking? When does it change? What do you do when you are approaching orgasm? Do you say anything? What sounds do you make?

Pay close attention to everything you say and do and make careful mental notes that you can transfer later into your notebook. Use the questions on Sample Page 7 as a guide. Do not try to change any of your behavior right now. You are a scientist, so all you want to do is to observe. Repeat this exercise several times to scientifically validate your findings.

Sample Page 7

(COPY AND COMPLETE)
General Observations:

When you want to make love, how do you let your partner know? What do you say? What do you do?

When you start to get excited, how do you act? What do you say? What do you do?

Once you and your partner are making love, how do you communicate with him? What do you say? What do you do?

As you approach orgasm, how do you act? What do you say? What do you do?

When you sense that your partner is approaching orgasm, how do you act? What do you say? What do you do?

What other sexy words and phrases do you use before, during, or after lovemaking?

What other sexy sounds do you make?

What has this exercise made you notice about yourself that you never noticed before?

∼

Are You Surprised? I'm Not

Many of us are so preoccupied with one thing or another when we are making love that we fail to notice many of the nuances that can make it so special. But if you've been a good scientist during these two exercises, you've probably been noticing all kinds of new and surprising things about yourself and your partner. Perhaps one of the first things that you noticed is that your partner makes a lot of noise when he is making love. His breathing changes; his level of excitement changes; he may moan or groan. He may even say sexy things. What a shock that must have been!

By now you may have hundreds of pages of detailed notes (well, at least a few pages). All of this makes for great bedtime reading—anytime reading, for that matter—but that's not the half of it. In the third and final exercise in this chapter you are going to put your astute observations to work, and the results are bound to both surprise and delight you.

Exercise 8: Echoes in the Night

(SOLO)

You are no longer a research scientist; you are now a copycat. The goal of this exercise is to imitate all of the sounds your partner makes as the two of you are making love. It is important to be sincere, and as unobtrusive as possible. Here's how to do it: If he moans, moan with him. If he groans, groan with him. If he starts to breathe heavily, breathe heavily with him. If he makes little noises, like "ooh" and "aah," do the same thing. If he cries out, you cry out. If he starts talking sexy—well, that one is up to you, since I said you didn't have to start talking yet.

Continue your mimicking behavior all the way through your partner's orgasm. Then, the next time you are alone, record what happened in your notebook.

Sample Page 8

(COPY AND COMPLETE)

Changes I noticed in my partner during this exercise:

Changes I noticed in myself during this exercise:

A lot of people giggle when they read Exercise 8 for the first time. They think that making noises like this seems silly, and they can't imagine how it could possibly enhance their lovemaking. Are you feeling the same way? Then let me tell you a story—a true, and very typical story about one of my clients.

The Story of Anna M.

Anna M. came to me for counseling after being referred by her closest friend. Anna loved her husband very much, but their sex was lifeless, bordering on intolerable. Anna told me she was absolutely tongue-tied in bed. She never said a word. She said, in fact, that she was so self-conscious she couldn't even make noise.

Anna desperately wanted things to change, which was a strong motivator, but she really didn't know where to begin. She started by reading several popular sex books, but that didn't help. On the contrary, it made her feel like everyone else on the planet was more liberated than she was. Determined to keep trying, Anna was then courageous enough to look at a few soft-core instructional videos. What she saw excited her—particularly the way the man and woman talked to each other—but she just couldn't picture herself saying sexy words or asking for sexual things.

It was at this point that Anna came to my office for the first time. After listening to Anna

share her experiences and her frustrations, I knew we needed to introduce change in the slowest, most gentle fashion. So the very first thing I did was give Anna Exercise 6 as a homework assignment. Anna loved this assignment because she didn't have to do anything but observe her husband while they were making love. Lo and behold, the very first thing Anna observed was that her husband actually made a *lot* of noise—all kinds of noise. Anna was fascinated by this discovery. She had always been so consumed by her own "internal dialogue of dissatisfaction and fear," as she phrased it, that she had never noticed how expressive her husband was.

Anna's second assignment was Exercise 7, which proved to yield equally surprising results. Anna had originally told me that she never made as much as a peep in bed, but what she discovered by observing herself was that she actually made a number of very subtle noises at different moments during lovemaking. Even she had to admit that she was not the ice cube she portrayed herself to be.

Anna's third assignment, Exercise 8, proved to be the breakthrough assignment. She started off very slowly, moaning softly every time her husband moaned. Anna was able to do this with a minimal amount of fear once she realized that if she timed her moans right, they went practically undetected, being covered up by the louder moans of her partner. This actually gave her a chance to get comfortable consciously moaning at various volumes.

After a little bit of practice, Anna noticed that her moaning became almost automatic, just like breathing. She also noticed that she was getting comfortable moaning at louder and louder volumes.

As Anna's volume increased, something else began to happen—something she never expected. Though he was still not conscious that Anna was doing anything different, her husband started responding to her sounds. On a subliminal level, his body was beginning to get the message. He was clearly getting more excited during sex, and his moans became louder and faster. Well, these changes got Anna excited too. The next thing she knew, she was moaning louder and faster with him.

Within days, Anna was looking forward to having sex more than she could ever remember. Making noise was becoming more and more natural, and more and more exciting every time. Then one night, after a particularly intense twenty minutes of intercourse, Anna and her husband looked at each other in awe, and said simultaneously, "What happened?"

At this point, Anna told her husband, "Remember the therapist I went to talk to? She told me that making a little noise might help me feel more sexual, so I tried it." Her husband cracked a huge smile and said, "Did she have any more advice?" Well, that was all that Anna needed to hear. Three days later she was back in my office telling me: "I want to learn to talk sexy!" The sudden change in her personality was so striking I just had to

laugh. Here was this self-described "remnant from the ice age" asking for all kinds of exercises and advice that could get her and her husband talking up a storm.

So what's the moral of this story? I guess it's this: Just because you're feeling a bit tongue-tied, it doesn't mean that you are powerless. As Anna M. discovered, even a few simple sounds can mark the beginning of monumental changes in your sex life, and your relationship as a whole. So give Exercise 8 a try. Before you know it, you may just have your partner begging for more. And believe me, there is plenty more in store.

Your Precious Parts

WHEN it comes to talking sexy, no two people are quite the same. Some of us are frustrated because we can't speak a single sexy word. Others are frustrated because they can't run off a string of raunchy expressions. But whoever you are, you have to get comfortable with yourself before you get comfortable talking sexy to your partner.

Getting comfortable with yourself begins with getting comfortable with your own body. Now I realize that that is no easy task. I've met very few women in my lifetime who truly love their own bodies. The media has done a fine job of giving us standards of physical perfection that are nothing less than impossible to measure up to. But we try. And try. And plastic surgeons, fashion design-

ers, and cosmetic company executives get very rich in the process.

It's time to put your credit cards away and take out your notebook. In this chapter, you're going to learn how a few simple words can do more for your body image than all of the clothing, makeup, and liposuction you could ever afford. Thus far, the only word I've asked you to say out loud is the word "yes." But, according to my calculations, you should be ready for more by now, and in this chapter we're going to do some serious vocabulary building. So sharpen your pencils and clear your desks of everything but your notebooks. It's time to get busy.

Your First Anatomy Lesson

The whole, they say, is always greater than the sum of its parts. But sometimes, you've got to pay a little more attention to those parts—especially the private ones—to make a relationship more whole. I'd like to start this chapter by turning your attention to the parts that are nearest and dearest to you: your breasts, your buttocks, and your vagina.

I want to begin with the vagina (yikes, that sounds just like a man!). But before we go any further, there is something I need to say: *Vagina* is not a sexy word. It just isn't. Whisper it, pant it, or scream it at the top of your lungs—no matter how you say it, it doesn't get anybody hot. But we're talking about something very, very sexy

here. The Big V. Ground zero. Our most precious possession. That which men have died for. We need to make it *sound* as sexy as it *is*. And that's what Exercise 9 is all about.

Exercise 9: My Secret Garden

(SOLO)

How many different words and expressions (sexy, slang, anatomical, literary, etc.) do you know for *vagina*? It's time to find out. Open your notebook to a fresh page and start writing them down (See Sample Page 9). Having trouble? Start with a five-letter synonym for kitty cat that ends in -*sy*. How about a four-letter word that starts with a "c" and rhymes with hunt? Have you ever heard the expressions *precious, mound, garden, triangle, love box, jade gate, vadge, snatch, hole, gash,* or *passion pit*? You have now. Put them on your list if you like, or stick to your own favorites. I think you get the idea. Brainstorm like crazy until you're tapped out. When you're done, put an asterisk next to the ones that really turn you on.

Sample Page 9

(COPY AND COMPLETE)

Vagina

Exercise 9a: Making Your Garden Grow

(SOLO)

Once you have completed your list, put your writing utensil down and get thee to a large mirror. Sit or stand in front of the mirror so you have a good view of your body. Some women enjoy doing this part of the exercise nude, and you certainly have that option, but feel free to stay fully clothed.

Look at the list you have just completed in your notebook, and at the first word or expression on that list. Look at yourself in the mirror. Now look at your vagina. Continue to look at your vagina, as though it were the focus of your meditation. Now, *without making any sound*, simply mouth the first word on your list. Mouth it slowly, feeling the way your lips and tongue move. Now mouth it again. And again. And again. And again.

Now, in the lowest of whispers, whisper the word. Just whisper it. Whisper it again. And again. And again. And again. And again.

Keep your eyes focused on your vagina. Now try to whisper a little louder. Then a little louder still. Whisper the same word over and over and over.

It's time to try a stage whisper. Gather up all of your courage. Now, in the strongest stage whisper you can muster, say your word. Say it again. And again. And again—until you are completely comfortable saying the word out loud. Now take a short break. After your break, return to your list on Sample Page 9. What I would like you to do

next is to go through every word and expression on your list, one by one, repeating all of the steps you have just completed for the first word. Start by silently mouthing each one, and gradually work your way up to a stage whisper. Remember to look in the mirror. Take your time and savor each word. You don't have to do this all in one sitting, but it's important to try as many words and phrases as possible. Be sure to pay special attention to any words or phrases you've marked with an asterisk.

Congratulations! You've done it. You're really talking sexy! How does it feel? Is it easier than you thought it would be? I'm not surprised. Well, now is no time to stop. We're just getting started! If you've followed the instructions carefully, you've covered the vagina pretty thoroughly. It's time to cover your butt—and all the rest too!

Exercise 10: Body Builder

(SOLO)

Turn to a fresh page in your notebook and write down the word *breasts*. Underneath that, write down as many words and expressions (sexy, slang, anatomical, literary, etc.) you can think of for the word *breasts*. Start with simple ones like *bosoms, tits, globes, jugs,* and *melons*. Try to get at least nine or ten (if you get to fifty, you may want to stop). Next, write down the word *buttocks*. Underneath that, write down as many words and expressions you can think of for the word

buttocks. Some obvious ones are *behind, butt, rump, ass,* and *rear end.* How many more can you think of? Be creative! Let's not forget the anus. Write that down too. What other words or expressions do you know for *anus?* Write them down.

Now write down the word *clitoris.* Write it down again, but leave off the "oris." Can you think of any other words or expressions (sexy, slang, anatomical, literary, etc.) for clitoris? What about *button* and *love button?* Or *man in the boat?* Frankly, I don't know many other expressions for the clitoris. But you might. If you do, write them down.

Finally, write down the words *pubic hair, labia,* and *nipples,* along with any synonyms, expressions, or pet names for these three that come to mind. Next to pubic hair, I'd write down *pubes, bush,* and *jungle.* Next to *labia,* I'd write down *lips* and *flaps.* Next to *nipples,* I don't know *what* I'd write. But of course, that's just me. What comes to your mind? Write it all down. And don't get uncomfortable if you can't think of anything. As far as these three words are concerned, I think there's an acute shortage of sexy synonyms for all of them.

We've covered the obvious, now let's handle the rest. What other parts of your body excite you? Your thighs? Your neck? Your lips? Your toes? Your ankles? Your armpits? Think carefully now. And don't get embarrassed—no one has to know but you. If it turns you on, no matter what it is, write it down. Then write down any nick-

names you have for each part you've added to
your list.

When you are done, review all of your lists
and place an asterisk next to the words and
phrases that turn you on most.

Sample Page 10

(COPY AND COMPLETE)

1. Breasts

Bosoms

Tits

Globes

Jugs

Melons

2. Buttocks

3. Anus

4. Clitoris

5. Pubic hair

6. Labia

7. Nipples

Other parts of my body that turn me on:

Exercise 10a: Body Beautiful

(SOLO)

With your lists from Exercise 10 in hand, sit or stand in front of a large mirror. If you feel comfortable nude, you may wish to take your clothes off at this time.

Take a good look at your breasts in the mirror. Cup them in your hands if that's comfortable for you. Now, *without making any sound*, mouth the word *breasts*. Continue to look at your breasts. Slowly mouth the word *breasts* again,

feeling the way your lips and tongue move. Then mouth it again.

Now, in the lowest of whispers, whisper the word *breasts*. Just whisper it. Whisper it again. And again. Keep looking at your breasts. Touch them if that feels comfortable. Now make your whisper a little louder, then louder still. Repeat the word *breasts* over and over again. Finally, in your strongest stage whisper, say the word *breasts* five or six more times until you are completely comfortable saying it out loud.

Take a short break. After your break return to your lists from Exercise 10. What is the first word or phrase you wrote down next to the word *breasts*? I want you to work with that word or phrase the same way you just worked with the word *breasts*. Start by silently mouthing it several times. Next, say it in the lowest of whispers. Slowly work your way up to a stage whisper, remembering to always look at your breasts as you say each word or phrase.

When you are finished with the second word or phrase on your list, move on to the third one. What I want you to do is to continue working through *all* of the words and expressions on your list the way you have just worked with these first few words. Take your time, letting the experience of hearing yourself say each word or phrase over and over sink in.

When you are done with all of the words and phrases on your "breasts" list, turn to your "buttocks" list. Starting with the word *buttocks*, work your way through every word and phrase on that

list. Be sure to look at your buttocks in the mirror as you are speaking. You may even want to caress them with your hands as you talk.

Are you getting the idea? Proceed, word by word, phrase by phrase, through the remainder of your lists from Exercise 10. Remember that as you are talking you always want to focus your attention on the part of your body that you are talking about. Stare at each part, if you can. Stroke each part if you wish (it adds a lot to the exercise). Pay attention to how each word or phrase makes you feel. Give special attention to the ones you've marked with an asterisk.

When you have practiced saying all of the words and phrases from all of your lists, take a few moments with your notebook to reflect on the experience of doing this exercise (see Sample Page 10a).

Sample Page 10a
(COPY AND COMPLETE)
Saying these words made me feel

The words that turned me on the most were

～

Exercise 11: Mirror, Mirror

This is a body image exercise. Stand in front of the mirror and take a good look at every inch of your body (it is most effective to do this exercise in the nude, but it is not essential). Now touch each part of your body. As you touch yourself, describe what each part feels like (soft, smooth, firm, strong, warm, cool, etc.). Talk to yourself about each part in as much detail as possible. Imagine you were writing a poem about each part. What would you write?

Sample Page 11
 (COPY AND COMPLETE)
 Notes on Exercise 11:

~

Appreciating Your Body Even More

Now that you are so acutely focused on your body, there is one more exercise I'd like you to try. But to do this exercise, you need to become familiar with a technique called the genital caress. The genital caress is a structured sensual way of touching designed by sex therapists to help men and women focus on, appreciate, and control the moment-to-moment experiences of genital con-

tact, arousal, and release. It is not a sex act. It is simply a loving, pleasurable way of making contact with yourself or with a partner.

To perform a genital caress on yourself, the first thing you need to do is lie on your back and get very comfortable. Ideally, you don't want to be wearing any clothing, but this isn't mandatory (*nothing* about sex should be mandatory). What you will be doing is slowly, gently, caressing your body, focusing on those parts that you find sexually stimulating. You may want to begin with your breasts, for example, or with your neck or your hair. Pay careful attention to what each part of your body feels like and what it looks like. If you have taken off your clothing, you might want to use baby oil or some other lubricant to enhance the sensuality of the experience. Continue to caress your body, getting more and more focused on your genitals. Slowly explore all of the parts of your vagina, including your clitoris, outer labia, and inner labia. But do note that reaching orgasm is not the goal of the genital caress; the goal is simply a full appreciation of the sensations you are experiencing.

As you will see in Exercise 12, this genital caress is going to help you access erotic thoughts and feelings that you have probably been keeping from your partner, and possibly keeping from yourself as well.

Exercise 12: Touch And Tell

(SOLO)

Lie down in bed, get very comfortable, and begin a genital caress. As you touch yourself, say

whatever comes to your mind. Let it come out in a stream of consciousness. Try not to censor anything. Your stream might include moans, grunts, words, sentence fragments, random thoughts, descriptions of your body, descriptions of what you are doing, descriptions of what you are feeling, or descriptions of fantasies that are being triggered by your caresses.

Caress yourself for at least fifteen minutes, and try to keep talking the entire time, even if the only thing that comes out of your mouth is gobbledy-gook. It doesn't matter if you are being silly, serious, outrageous, or incomprehensible. You don't need to make a single bit of sense. All you need to do is let yourself go. When you have finished, take a few minutes to write about the experience.

Sample Page 12
(COPY AND COMPLETE)
Notes on Exercise 12:

∼

His Precious Parts

W HEN it comes to making love, your body is only half the story. There's going to be a man lying next to you (or on top of you, or beneath you, or behind you, or . . .) and you need to appreciate every nook and cranny of his body too.

If you've completed Exercises 9 through 12 you've done a great job getting to know and appreciate the sexiness of your own body. But you could use a break. It's time to take the focus off your body for a while and put it on the body of the one you love. And I think the best place to begin is the most obvious place. I'm talking about "man's best friend," that extraordinary piece of equipment that's always getting so much attention in the media these days: the penis.

When Sigmund Freud coined the phrase "penis

envy" one wintry evening in Vienna, little did he know that he would be giving millions of us the opportunity to say the word *penis* in mixed company for years to come. Granted, Freud may have been a bit off the mark with his concept. Personally, I think men spend a lot more time envying penises than women do (which may be why men take so long to shower after the big game). But you have to give Siggie credit where credit is due. He took the word out of the closet and put it on the tip of our tongues, and that makes him A-okay in my book.

Do you think the word penis is sexy? It's certainly a lot sexier than *vagina,* that's for sure. But I have to admit, I can think of a lot of other words and phrases that make a man's penis seem a lot sexier (I think I lost count at around sixty). Can you? It's time to find out. Exercise 13 is my little homage to the man who gave me my career. Enjoy it—I think he would have.

Exercise 13: Freudian Slip

(SOLO)

Open your notebook to a fresh page. At the top of the page, write down the word *penis.* Underneath the word *penis*, write down as many words and phrases your can think of that are synonymous with penis (sexy, slang, anatomical, literary, etc.), placing an asterisk next to the ones that turn you on most.

The first two words that always come to my mind both have four letters and end in *-ck.* I think of them both every time I look at my watch

since one rhymes with tick and one rhymes with tock. But there are oh-so-many more. There's *member,* for example, and *manhood* and *prick* and *hard-on* and *schlong* and *pole* and *staff* and *weapon* and *tool* and *thing* and *jade stalk.* And what about words that describe the tip of his penis—words like *head, helmet,* and *crown.* I think it's pretty obvious that I could go on and on, but this is your exercise. Let's see just how long a list you can come up with. (See Sample Page 13).

Sample Page 13
(COPY AND COMPLETE)
Penis

Exercise 13a: Cigar Aficionado
(SOLO)

Find a comfortable chair to sit in, or lie down on your bed. You might enjoy taking your clothes off for this exercise, but it is not necessary. You also might enjoy having your favorite vibrator and a fresh set of batteries nearby.

I want you to think about the word *penis.* Now close your eyes and try to visualize your lover's penis. As you are doing this, slowly mouth the word *penis* without trying to make any sound. Just feel the way your tongue and lips move as you say it. Say it again. And again. And again.

Now, in the lowest of whispers, whisper the word *penis*. Whisper it again and again and again. Keep your eyes closed and keep thinking about your lover's penis. Think about the way it looks; think about what it feels like inside of you. Keep whispering.

Whisper the word a little louder. Louder still. And louder still. Once you have reached the level of a stage whisper, you can stop. After you have stopped whispering, keep your eyes closed for a little while longer and let the image of your lover's penis linger. Now open your eyes.

Repeat this process for all of the words and phrases on your "penis" list, paying special attention to the ones you marked with an asterisk.

~

The Right Stuff

There's an old Lithuanian expression my great-aunt was fond of quoting that goes something like this: "A penis does not a man make." (Actually, the translation is mine, since she never did learn to speak English.) She was so right. I think testicles are fascinating and fabulous. And I know very few women who aren't totally turned on by a man's butt. Men even have sexy nipples (though they can be a bit hard to find sometimes if the guy is kind of hairy). Frankly, I don't think this is quite what my great-aunt had in mind; I think she was trying to be a bit more profound. But it's what she *should* have had in mind. It's certainly what's in

my mind right now, and what ought to be in yours.

The point I'm trying to make here is that little boys may be made of frogs and snails and puppy dogs tails, but grown men have a list of far more interesting ingredients, and we need to get comfortable talking about *all* of those sexy ingredients. Exercise 14 is going to get you started.

Exercise 14: Male Call
(SOLO)

Take out your notebook and turn to a fresh page. At the top of the page, write down the word *testicles*. Underneath that, write down the word *scrotum*, the word *balls*, and the word *sack*. Get a cool drink from the icebox and take a few sips. Now write down every other word or phrase (sexy, slang, anatomical, literary, etc.) you can think of that is synonymous, in your mind, with *testicles*.

Start a new list. At the top, write down the word *buttocks*. Underneath that, write the words *butt, buns,* and *ass*. Now write down every other word or phrase you can think of that, in your mind, conjures up the image of a man's buttocks.

Do you have any pet names for a man's *semen*? *Come* and *jiz* pop into my mind pretty quickly. Do you have any pet names or synonyms for his *pubic hair*, his *foreskin*, his *nipples*, or his *anus*? Write all of these down.

And what other parts of his body do you find sexy? If thinking about something makes you tingle, be sure to put it on your list, along with any synonyms or nicknames you have for those vari-

ous parts. For example, I think words like *thigh*, *navel*, *chest*, *tongue*, *biceps*, *toes*, and *lobes* can be pretty sexy when used at the right moment; even the word *nostril* turns a few women on. Please note: A yacht can be very sexy, but it is not a part of the body and does not belong on this list.

When you have completed all of your lists, place an asterisk next to the words and phrases that turn you on most.

Sample Page 14

(COPY AND COMPLETE)

1. Testicles
Balls
Scrotum
Sack

2. Buttocks
Butt
Buns
Ass

3. Semen

4. Pubic hair

5. Foreskin

6. Nipples

7. Anus

Other parts of his body that turn me on:

Exercise 14a: Man Talk

(SOLO)

Once again I want you to lie down on your bed or find a comfortable chair to sit in. Close your eyes and start to think about your lover's body. Now focus all of your attention on his

testicles. As you visualize his testicles in your mind, slowly mouth the word *testicles* without making any sound. Mouth it again. Feel the way your tongue and teeth make contact. Mouth it again.

Now, in the lowest of whispers, say the word *testicles* out loud. Keep your eyes closed and keep the image of your lover's testicles ever-present in your mind. Whisper it again and again and again. Raise your voice ever so slightly and whisper it again. And again. And again. And again. Continue to raise your voice, saying the word *testicles* over and over again, until your voice has reached the level of a stage whisper.

Open your eyes. The next word on your list is *balls*. Close your eyes once again and repeat all of the above steps, this time, saying the word *balls*. Continue on in this fashion through all of the words and phrases on your "testicles" list.

Your next list is the "buttocks" list. With your eyes closed, and the image of your lover's buttocks clear in your mind, practice whispering all of the words on the *buttocks* list by following the above steps.

When you have finished with your lover's butt, work on his semen, his pubic hair, his foreskin, his nipples, his anus, and any other body parts you have written down in your notebook. Practice each word or phrase over and over until you feel extremely comfortable whispering them out loud, giving special attention to the ones you have marked with an asterisk.

Sample Page 14a

(COPY AND COMPLETE)

Saying these words made me feel . . .

The words that turned me on the most were . . .

Just for Laughs

I TAKE sex very seriously. I have studied human sexuality for more than ten years. I've written three books about the subject. I have taught in various colleges, and I lecture throughout the United States and Europe. Like I said, I take sex very seriously. But that doesn't mean you should. *Nothing adds more spice to lovemaking than a dash of humor.* And let me tell you, it took a long time for me to learn this. When I was younger, I was serious about *everything*. But one night at a dance club in Los Angeles all of that changed.

It was disco madness in L.A. *Saturday Night Fever* was the rage (I hope I'm not dating myself *too* much) and my feet were worn out. So I decided to take a breather in the ladies' room. Anyway, there were three extremely attractive

women, who were obviously close friends, fresh-
ening their makeup in front of the mirrors and
comparing notes with each other about their
dates. It was a classic scene: Every ear was tuned
to this three-way conversation, yet the three
women were barely aware that anyone else was
even in the room. That's when one of the women
began to describe her previous evening. "I could
hardly believe it," she began, "but we laughed
and laughed and laughed till we fucked . . . then
we laughed even more . . . and then we fucked
even more . . . I've never been so turned on."

I could hardly believe it as well. Laughter an
aphrodisiac? Well, I've never forgotten that night
or her words. It changed my attitude toward
lovemaking and I'm hoping that today it will
change yours. Humor is an incredible turn-on
before sex, during sex, and after sex. Sex can be
very funny. Everyone knows that sex can be
pretty exciting. It can be dramatic. It can be gor-
geous. It can be intoxicating. It can be exhaust-
ing. And it can be dirty. But you also need to
know that sex can be *fun*. And if you give me a
chance, I'll prove it to you.

Smile When You Say That

Every woman has her share of old boyfriend sto-
ries and I guess I'm no exception. Though many
of my relationships were eminently forgettable,
the funniest ones were not. I remember, for exam-
ple, one man who gave me a pair of underwear

with a little tag in it that said, "If found, please return to. . . ." Next to that he had printed his name and phone number. This same guy used to joke a lot about how much guys masturbate. He swore he was going to get rich marketing a palm tattoo for men that said: FOR MEMBERS ONLY.

It seems like lots of men get a kick out of giving women's private parts humorous nicknames. Over the years, for example, I've had my vagina dubbed quite a wide variety, including "the Promised Land," "the den of iniquity," "pumpkin patch," "heaven's gate," "Mrs. Jones," "the princess," "Love Canal" (I think that guy was a little hostile), "home sweet home," "the Bermuda Triangle," and "the Holy City."

And what about humorous nicknames for *him*? I think every woman has at least one funny nickname for a man's penis. Some perennial favorites, for example, are "dork," "wiener," "weenie," "pee pee," "hot dog," "sausage," "trouser snake," "serpent," "lizard," "monster," "lieutenant," "colonel," "sergeant," "captain," and "Mr. Doozey." And that's not even scratching the surface. I remember being interviewed on a radio show once where women were invited to call in and offer their favorite nicknames for the penis. It was a hoot! And I *still* laugh when I think about the one woman caller who said, "I call it Richard, because it's long for dick."

I guess my point is that there are *so* many fun nicknames for the penis. I'm sure you can add to the list, and in the next exercise, you're going to get that chance. So take out your notebook and your funny bone and get back to work.

Exercise 15: Funny Girl

(SOLO)

Open your notebook to a fresh page and write down the word *vagina* (see Sample Page 15). What *funny* words, expressions, pet names, nicknames, etc., come to mind? Write them all down. If any of the words or phrases I've already mentioned made you smile or laugh, include them in your list.

Now write down the word *penis*. Beneath it, make a list of every *funny* word, expression, pet name, nickname, etc., that comes to mind. Once again, include any of the words I've already mentioned if they amuse you.

Proceed in this fashion through the words *breasts, testicles, clitoris, buttocks* (his *and* yours), *nipples* (his *and* yours), *anus* (his *and* yours), *pubic hair* (his *and* yours), *labia, semen,* and *fore-skin.*

Sample Page 15

(COPY AND COMPLETE)

1. Vagina

2. Penis

3. Breasts

4. Testicles

5. Clitoris

6. Buttocks

7. Nipples

8. Anus

9. Pubic hair

10. Labia

11. Semen

12. Foreskin

~

Once you have completed all twelve lists I want you to practice saying these words and phrases out loud. Start in the lowest of whispers and build from there. Experiment with all different kinds of tones and expression. Say it with a smile. Then say it like you mean it. Try to make yourself laugh. Then try a total deadpan. Whatever you do, make sure you're having fun!

Words to Live By, Words to Love By

W HAT'S in a word? Plenty, if it's one of the many sexy words that comes to my mind right now. What sexy words are coming to mind for *you* right now? Is it a little scary to even think about them? Hopefully, by the time you've completed the exercises in this chapter, you'll have a very different feeling.

The Federal Communications Commission doesn't publish a list of things you can't say to your partner in bed. They don't have to. Each of us has our own internal censor that stops us from saying many of the things that are on our mind. But if it's in your thoughts, it's a part of who you are, and that part needs to come out and introduce itself.

In the previous three chapters we started that introduction. Were you surprised by all of the words and expressions that came tumbling out of your head and onto your paper? Were you even more surprised by how exciting it felt to say those words aloud? Well, you ain't seen nothin' yet. You've dipped your toe into the pool a few times now. You've even splashed around a little bit. But it's time to take a deep breath and really dive in.

A Little Grammar Goes a Long Way

For the past ten years I have taught students everything from basic introductory psychology to the most sophisticated classes in psychopathology and human sexuality. Though the course material varied dramatically, most of these classes have had one basic element in common: writing assignments. I have probably read and corrected thousands of papers: term papers, reaction papers, final papers—you name it. While I am always most concerned with the content of this writing, I have to admit that I am also a stickler for good grammar.

Now why am I telling you this? Because we need to talk for a moment about grammar. In the previous chapter, you did a lot of brainstorming for words and phrases that are synonymous with *vagina, penis,* and other words. You may have noticed that all of these words and phrases are nouns. A noun, as the dictionary tells us, is a word that denotes a person, thing, or action. Now there's nothing wrong with nouns; as you

have just seen, nouns can be pretty sexy. But what about all of those sexy verbs and adjectives out there just waiting to be set free? Sexy nouns can certainly spice up a sentence, but a nasty noun sitting dangerously close to a hot adjective or a sizzling verb can taste like five-alarm chili in your mouth.

Get the picture? Good. Then take a look at Exercises 16 and 17.

Exercise 16: Expletive Not Deleted

(SOLO)

Open your notebook to a fresh page and get ready for a little more brainstorming. What I want you to do is write down as many sexy verbs as you can think of, placing an asterisk next to the ones that turn you on most (see Sample Page 16).

I'll help you get started. Try these: *kiss, lick, nibble, tease, screw, bite, touch, suck, play, eat, chew, push, pull, brush, taste, rub, grind, stick, jam, blow, squeeze, fondle, smell, caress, grab, hump, swallow, spank, drink, thrust.* Get the idea? Now it's your turn. If you're starting to blush, remember that all of these words can be found in the *Scrabble Word Dictionary.* Hopefully, you'll also think of a few that can't be, like the one that starts with an *f* and ends with a *k*, and burns lots of calories, no matter what time of day.

Once you have completed your list I want you to practice saying these verbs out loud. Start with the first word on the list, *kiss.* Mouth the word silently a few times. Then try saying it in the low-

est of whispers. Gradually build from there. Experiment with all different kinds of affect too. Once you have comfortably reached a stage whisper, move on to the next verb on your list and begin again. Proceed in this fashion through your entire list, paying special attention to the ones you've marked with an asterisk.

Sample Page 16

(COPY AND COMPLETE)

My sexy verb list:

Kiss

Lick

Nibble

Tease

∼

Exercise 17: Wet and Nasty

(SOLO)

Turn to a fresh page in your notebook. This time, I want you to write down as many sexy adjectives as you can think of, placing an asterisk next to the ones that turn you on most (see Sample Page 17). Once again, I'll help you get started: *juicy, big, soft, wet, hot, lovely, aching, gorgeous,*

sweet, slippery, greedy, magnificent, nasty, tasty, hard, round, firm, wild, luscious, erect, tight, huge, naked, steamy, bare, throbbing, strong, erect, swollen, lovely, stiff, gentle, raging, hungry. Don't be embarrassed. You'll see at least one or two of these words every week in your newspaper's crossword puzzle.

After you have completed your list I want you to practice saying these adjectives out loud. Start with the first one on your list: *juicy.* Mouth it silently a few times. Now say it over and over again in the lowest of whispers. Gradually build from there until you have comfortably reached a stage whisper. Proceed in this fashion through every sexy adjective on your list, paying special attention to your favorites.

Sample Page 17
(COPY AND COMPLETE)
My sexy adjective list:
Juicy
Big
Soft
Wet
Hot

You've Got It All . . .

How are you doing so far? Are you having fun playing with all of your new words? If school had been this much fun, I bet that none of us would have ever graduated! Well, believe it or not, the best is yet to come. And speaking of come, did you get that one on your verb list? (hint, hint—you can put it on your noun list too).

Hopefully by now you've got pages and pages of all kinds of naughty nouns, verbs, and adjectives. You have expanded your vocabulary in ways you could have never dreamed possible. Granted, you haven't said any of these words in front of your partner yet, but trust me, it won't be long now (and speaking of *long* . . .). But what are you going to *do* with all those words? Not to worry. Once you've completed your verb and adjective lists, you will have assembled all of the ingredients you need to start making hot, sexy sentences. And that, my friends, is what the next chapter is all about.

Kiss My What?

SOMETIMES it only takes a word or two to light a fuse. But other times, nothing less than a sentence will do. Our trusty dictionary defines a sentence as "a group of words that state something, usually containing a subject and predicate." If you didn't learn about subjects and predicates in school, you don't need to learn now in order to make a sexy sentence. In the exercises that follow, I'm going to give you all of the guidelines you need to make an endless supply of wonderful, fabulous, juicy, sexy-as-hell "groups of words that state something." And it doesn't end there. You're also going to have the opportunity to string a bunch of very sexy sentences together into some really steamy prose. It doesn't get much hotter than this.

The exercises in this chapter were inspired by

a popular party game I used to play when I got too old for my Colorforms but was still too young to play spin-the-bottle. The game, as many of you will remember, was called Mad-Libs. It's probably just as popular today as it was when I was a kid, but I wouldn't really know since I haven't been on the party circuit since my prom.

What I always enjoyed most about playing Mad-Libs was when someone created a "naughty" sentence by accident. I'd blush so that my face would turn beet red, then I'd laugh so hard, I could hardly breathe. Who would have thought that one day, I would be using a similar style of fill-in-the-blank sentences as a teaching aid to actually help people overcome their discomfort with provocative language. Who would have thought that by intentionally creating and reciting loving, sexy, or steamy sentences, people could learn to communicate better with their lovers and tap into their true erotic potential. But it works! That's why it's party time once again. Only this time, I don't want you to get mad, I want you to get *bad*—really bad. Let's get started with Exercise 18.

Exercise 18: Bad Libs

(SOLO)

On Sample Page 18 you will see ten incomplete sentences. Your job is to complete these sentences by filling in the blanks with sexy nouns, verbs, and adjectives where indicated. These nouns, verbs, and adjectives should come directly from

the lists you created in Exercises 9, 10, 13, 14, 15, 16, and 17, though you should feel free to improvise at any time.

Begin by copying the first incomplete sentence, as it appears on Sample Page 18, into your notebook. Beneath that, try to write at least half a dozen different complete sentences that express your romantic-sexual-erotic desires. Start with a few gentle ones; then heat it up a bit. Write a few more just for laughs. You'll see that I have completed one for you to help get you started. When you are done with Sentence 1, copy Sentence 2. Once again, complete the sentence in at least half a dozen different ways that express the full spectrum of your desires—loving, passionate, and down-and-dirty. Write a few funny ones too.

Proceed in this fashion through all ten sentences, marking the ones that turn you on most with an asterisk. Try to really take your time with this exercise. Be honest. Be creative. Be wild. Be silly. Be anything you want to be. But most of all, be baaaad.

Sample Page 18

(COPY AND COMPLETE)

Copy each sentence, and fill in the blanks as instructed:

Sentence 1: You make me so (adj.).

Example: You make me so hot.

Sentence 2: I want you to (verb) my (noun).
Example: I want you to kiss my breasts.

Sentence 3: You make my (noun) (adj.).

Sentence 4: Your (noun) makes me so (adj.).

Sentence 5: I want to (verb) your (noun).

Sentence 6: I want to (verb) your (adj.) (noun).

Sentence 7: I love it when you (verb) my (noun).

Sentence 8: I want to make your (noun) (adj.).

Sentence 9: I love to look at your (adj.) (noun).

Sentence 10: Thinking about you makes my (noun) (adj.).

Now it's time to read what you have written. Take a look at the first complete sentence you wrote beneath Sentence 1. Begin by mouthing all of the words in the sentence without making any noise. Repeat this several times. Imagine that you are actually saying this to your lover, and how that would feel.

Now try reading the sentence aloud in the lowest of whispers. Read it again and again and again. Whisper a little louder. Then louder still. Pretend that you are reading lines from a play, and start to experiment with various types of inflection. Note how certain types of emphasis are much more of a turn-on than others.

When you have rehearsed your first sentence enough times to feel comfortable, move on to the second sentence. Work your way through this sentence, and all of the sentences you have created in this exercise, paying special attention to the ones you have marked with an asterisk.

How did you do? Were you bad? Didn't it feel good? No reason to stop now. In the next exercise you'll find ten more bad libs, and this time they're *really* bad. Are you ready to push the envelope? Are you ready to lick it and stamp it too? Then get going!

Exercise 19: Really *Bad Libs*

(SOLO)

Copy Sentence 1, as it appears on Sample Page 19, into your notebook. Now complete the sentence at least half a dozen different ways by filling in the blanks with sexy words from the lists you created earlier (see my example.) Express your true desires. Then be sure to write at least one funny one!

Repeat this procedure for Sentence 2 through Sentence 10. When you are done, place an asterisk next to the ones that turn you on most.

Sample Page 19

(COPY AND COMPLETE)

Copy each sentence and fill in the blanks as instructed.

Sentence 1: (Verb) me! (Verb) me *now*!
Example: Kiss me! Kiss me *now*!

Sentence 2: (Verb) my (noun)!

Sentence 3: I love the way your (adj.) (noun) feels against my (adj.) (noun).

Sentence 4: I need to feel your (adj.) (adj.) (noun) inside my (adj.) (adj.) (noun).

Sentence 5: I love the way your (adj.) (noun) feels against my (adj.) (noun).

Sentence 6: I have to (verb) your (adj.) (noun)!

Sentence 7: I want you to play with my (adj.) (noun).

Sentence 8: Stick your (adj.) (noun) in my (adj.) (noun)!

Sentence 9: I want to make your (adj.) (noun) (adj.)!

 Sentence 10: (Verb) me like a (adj.) (adj.) animal!

Are you ready to read these bad libs aloud? When you are, take a look at the first sentence you just created. Begin by mouthing all of the words in this sentence without making any sound, and repeat this several times. Try to imagine what it would feel like to actually be saying this to your lover; imagine how he would be responding.

Now, in your lowest whisper, try to speak your first sentence out loud. Whisper it again and again and again. Try it a little louder, then louder still. Repeat it over and over. Make believe that you are reading a line from a play, and experiment with different interpretations.

When you have become comfortable saying your first completed bad-lib sentence out loud, move on to the second. Proceed in this fashion through all of the new sentences you created for this exercise, paying special attention to the ones you have marked with an asterisk.

Blending Fact with Fiction

Are you one of those women who insists she doesn't have a single fantasy inside her head?

You'll never say that again, if I can help it. Using your sexy word lists, these next two exercises will continue to sharpen your vocabulary skills, while helping you create some full-blown fantasies at the same time. Just follow the instructions, and you'll have at least two serious sizzlers generating major heat inside your cranium by the time you put your pencil down.

Exercise 20: Fantasy Fill-In

(SOLO)

Using the nouns, verbs, and adjectives from your sexy word lists to fill in the blank spaces as indicated, complete the paragraphs on Sample Page 20.

Sample Page 20

(COPY AND COMPLETE)

The Shower

I've been thinking all morning what it would be like to be enjoying a slow, sensuous shower, and turn to see you part the shower curtains and step in right beside me. I think about looking at your beautiful naked body, and watching your face as you eye my naked body longingly from top to bottom, and I imagine what it would feel like to embrace you, as the water cascades over us.

I fantasize that you would take a bar of my most luxurious soap and begin to cover me with lather. You'd start at the back of my neck, then oh-so-slowly work your way to my (adj.) (noun), my (adj.) (noun), and finally, my (adj.)

(noun). By the time you reach my (noun), I'll be on fire. Just feeling the soap glide across my (noun) will make my (noun) (adj.) and make me moan out loud with pleasure.

Before I climax from the incredible stimulation, I would take the soap from your hands, place it in mine, and turn all of my attention to your magnificent body. First, I'd slowly soap up your (noun). Then your (noun). Then your (adj.) (adj.) (noun). I'd massage you ever so slowly, till I saw, by looking at your (adj.) (noun) that you were so excited you probably couldn't take much more. Then I'd take you by the hand, step out of the shower, towel you off, towel myself off, and lead you into the bedroom.

When you have completed the fantasy, silently read it to yourself. Now, in a soft voice, slowly read it aloud, letting yourself experience the full effect of what you have created. Read it aloud one more time before moving on to the next exercise.

∾

Exercise 21: Another Fantasy Fill-In
(SOLO)

Using the nouns, verbs and adjectives from your sexy word lists to fill in the blank spaces as indicated, complete the paragraphs on Sample Page 21 as you did in Exercise 20.

Sample Page 21

(COPY AND COMPLETE)

The Seduction

Sometimes I think about what it would be like to spend a weekend together in a small cabin hideaway, deep within beautiful snow-covered woods. I'd be lying next to you in front of a warm fire, and one look into my eyes would tell you exactly what I wanted.

I think about how you would slowly undo my blouse, button by button. Then you would (verb) and (verb) my (adj.) breasts while I watched you, as though I were watching myself in a movie. Soon I'd be urging you to remove my skirt, my stockings, and finally, my panties. At the same time, I'd begin to undress you. I'd start by pulling open your belt, unbuttoning your slacks, and unzipping your fly so I could take a good look at your (adj.) (noun). I'd pull off your shirt so I could admire your chest and your arms. Then I'd tear off everything else you were wearing so you were naked and beautiful in front of me. For the next hour I would beg you to (verb) my (adj.) (noun) while I (verb) your (adj.) (noun). I'd plead with you to (verb) me and (verb) me, again and again, until we'd collapse into each other's arms, totally exhausted and fulfilled.

Once you have completed this second fantasy scenario, silently read it to yourself. Then, in a

soft voice, slowly read it aloud. To finish the exercise, read your fantasy aloud a second time.

~

How Low Can You Go?

Did you know that your voice actually gets lower in pitch (that is, huskier) when you are horny? It's true. I think it has something to do with testosterone levels in the body. But you don't have to wait to get horny for your voice to drop—you can drop it yourself. That will *make* you horny—and, if anyone's listening, it will make them horny too!

When it comes to talking sexy, it's not just what you say that makes you look and feel so sexy, it's also *how* you say it. In the next exercise, you're going to *feel* exactly what I mean.

Exercise 22: Deeper Still

Return to the bad libs you created in Exercise 18. Starting with the first bad lib, I'd like you to read each sentence aloud three or four more times, trying to make your voice more husky (lower in pitch) and sexy with each reading. As you do this, imagine you are actually talking to your partner. How does that feel?

Practice this voice deepening on all of the bad lib sentences you completed for Exercise 18. When you are done, use your sexy new voice to read the fill-in fantasies you created in Exercises 20 and 21.

~

How Loud Can You Get?

Sometimes there is nothing more erotic than say-
ing something sexy in the quietest of whispers.
But other times, such as in the heat of frantic
lovemaking, crying out sexy stuff at the top of
your lungs can be the ultimate high.

Up until this point, you've been keeping the
volume down and keeping your cool. Are you
ready to lose your cool? If you are, get yourself to
a room that's heavily soundproofed, and give
Exercise 23 a try.

Exercise 23: Twist and Shout

(SOLO)
If you have a radio or stereo in the room
where you are doing this exercise, turn it on and
crank it up. You are going to be talking very
loud, and the music will stop you from feeling
terribly self-conscious. (I know women who have
borrowed heavy metal CDs by bands like Metal-
lica and Dokken from their kids to do this exer-
cise.) If you don't have any music, do the best you
can.

Return to the first bad-lib sentence you cre-
ated in Exercise 19. Once again, imagine what it
would be like to actually say this to your partner.
Starting in the softest of whispers, read the sen-
tence aloud. Next say it in your best stage whis-
per. Now say it twice as loud. And twice as loud
again. Now shout it out. Shout it over and over.
Scream. Cry out. Imagine you're so full of pas-

sion you're climbing the walls. Hold nothing back. Then give your vocal cords a rest.

Move on to the next sentence you created. Once again, starting from a gentle whisper, work your way up to a roof-raising decibel level. Over the course of several days, practice this with all of your sentences from Exercise 19. Don't try to do this in one sitting—it could give you a serious case of erotic overload, not to mention laryngitis.

Want more? Go back to Exercise 18 and practice those sentences too.

~

Reading Your Mind

If you have completed Exercises 18 through 23 you have already done one whole lot of sexy talking. You've been serious, mysterious, dirty, and funny; you've purred like a pussycat and roared like a lion. But have you said what's really on your mind? What's really, really, *really* on your mind? It's time to find out.

Way back in Chapter 5, Exercise 3, I asked you to fearlessly conduct an erotic inventory of yourself and your needs. I asked you all kinds of questions about the kinds of sexy things you wanted to say, and how you would imagine yourself saying them. You've grown so much since then you may barely remember what you wrote, but I think it's important to refresh your memory right now. So if you would, please take out your notebook and prepare for a little trip down memory lane.

Exercise 24: I Want It

(SOLO)

Turn back in your notebook to Exercise 3: I Wish, I Want. Question 3 asked, "What sexy words and phrases do you wish you could say out loud?" Look at your answer to that question. Now read that answer out loud, exactly as it appears in your notebook. Read it over and over until you are comfortable saying everything you wrote.

Do the same thing with your answers to questions 7, 13, 14, and 16 in Exercise 3.

~

Are You Ready to Come Out and Play?

Exercise 24 concludes the first portion of our exercise program. If you have faithfully completed all twenty-four exercises, you have gone about as far as you can go flying solo. The remaining exercises in this book are *all* partner exercises, and that means it's time to bring *him* aboard. *But only if you're ready.* Talking sexy to yourself in front of a mirror is *very* different than talking sexy in front of another human being. Loving this person with all of your heart, and knowing that he loves you, does not necessarily make it any easier. Fact is, for many people, it makes it a lot harder.

That's why I need to make something very clear right now: If you are still feeling the slightest bit awkward or uncomfortable with all of the language you have been learning, there is no rea-

son to rush ahead. So don't. Far better, in fact, to go back—to the very beginning if necessary—and give yourself all of the time and practice you need to feel *truly* comfortable.

The partner exercises that follow are *very* low pressure and *very* easy to follow, *but you still have to be ready*. If you're not ready, don't try to force yourself. It doesn't matter how long it takes to get comfortable. Sooner or later, you *will* get comfortable. As far as I'm concerned, all that matters right now is that you are enjoying the process.

Of course, it's also possible that you're bursting at the seams by now; that you don't think you can wait another minute to start sharing what you've learned. Well, if that's the case, don't let *me* hold you back. Turn the page and get going!

Partners in Crime

IT'S time to start talking sexy to the one you love. Once you break the ice, you're going to generate enough heat to melt icebergs. But how do you begin? What do you say first? When do you say it? And how do you get the courage?

Relax. The exercises in this chapter are going to help you utter your first words in the presence of a partner. We're going to start off slow—*really slow*—keeping the pressure at a minimum and the excitement at a maximum. By the time this chapter is over, you'll feel so comfortable talking sexy in front of your partner you may never be silent again.

Ground Rules for Getting Started

Before you and your partner begin your first exercise together, I need to make a few things clear. All of the partner exercises in this chapter, and in the remaining chapters of this book, are what I call "pressure-free, demand-free" partner exercises (the more clinical term is "nondemand interaction"). There is only one goal: learning how to talk sexy to your partner, and having fun doing it. *These are exercises, not sex acts.* Sex is *never* mandatory, and sexual pressure is a no-no. There are no grades here. No good and bad, no right and wrong. All you're trying to do is talk.

If this is going to be a positive experience for both of you, you and your partner need to accept the following ground rules:

1: Read through each exercise together from start to finish before you try it. If necessary, discuss the exercise before you begin.
2: Both of you must feel completely comfortable with an exercise if you are going to try it. If either one of you has doubts, skip it. You can always return later.
3: I've recommended a time limit for every partner exercise. This is only a recommendation. Don't get upset if you lose track of time and go "over the limit"—it means you're having fun. Also feel free to shorten the time frame of any exercise, but be aware that you might not get the full benefit of an exercise if you're too rushed.

4: When both of you agree to do an exercise, you are agreeing to play along with whatever is called for. These exercises are far more fun if both people stay in character. If you don't think you can be a good sport, don't get started.

5: You are going to be doing a lot of talking. Both of you need to understand that it's just talk. There is a big difference between talking sexy and actually doing something about it. *It doesn't matter what you say or what you ask for*—you are under absolutely *no* obligation to ever deliver anything but words.

6: You need to trust that you can say absolutely anything to your partner, and vice-versa, free of judgment or criticism. If, at any time, either one of you is feeling judged or criticized, you need to communicate that immediately.

7: Sexual pressure destroys the value of any exercise. If either one of you is feeling pressured in any way, it is important to communicate that immediately to your partner—even if it's pressure that you are putting on yourself.

8: These exercises are very stimulating. If an exercise leads to sex, and you both want that, terrific. But *both of you* have to want it.

9: *If you are going to have sex, keep it safe!* I have written this book primarily for committed, monogamous couples who know each other to be safe from sexual risk. Yet I realize that not all readers are currently in such a relationship. If you are not in a committed, monogamous relationship, yet wish to practice these exercises with a partner, it is imperative

that you are always practicing safe sex techniques. Condoms *must* be used in exercises where there is physical contact, even if you are not having intercourse! If you use condoms as a standard birth control practice, I also recommend using them in any partner exercise where there is physical contact.

Just for Beginners

Are you ready? Is he? Then let's get started. The following three exercises are my absolute favorite beginner exercises for couples. While some may appeal to you more than others, I'd like you to try them all at least once.

Exercise 25: Magic Fingers

(20–30 MINUTES, WITH A PARTNER)

This exercise begins with your partner lying in bed, face down (minimizing eye contact will minimize the potential for embarrassment). He should be fully clothed. Dim the lights in the room, then sit next to him on the bed or lie stretched out next to him on your side. Remember your favorite nouns, verbs, and adjectives from chapters 7 through 10—the ones you marked with an asterisk? Your goal is to spell a bunch of these words out, letter-by-letter, on your partner's back using your index finger as though it were a pencil.

Write slowly, letting your partner guess each letter as you write it. If he guesses right, say yes and move on to the next letter. If he guesses wrong, say

no, and write it again. When you have finished spelling out the word, say, "That's it." You do not need to say the word out loud, and neither does your partner, though you can, of course, if you want to. You just need to be sure that he got it.

After you've done this with lots of words, try some of your sexy bad-lib sentences from Chapter 11 (or your sexy sentences from Chapter 5, Exercise 3). You're still doing this word by word, one letter at a time. But before you start to spell out the first word of your sentence, let your partner know that you're writing a sentence; then when you're done, let him know that you've finished.

Do you want to switch roles? If your partner is interested in switching too, lie face-down on the bed and let him spell out his own sexy words and sentences on *your* back.

Exercise 25 is the perfect exercise to practice over and over again. You have lots of new words and sentences to introduce to your partner, and this is probably the most low-pressure way to start—after all, the only words you have to say are *yes, no,* and *that's it.*

Once you've tried Exercise 25 a few times and you're ready to spice it up a bit, try Exercises 26 and 27.

Exercise 26: Bubble Talk
(40–60 MINUTES, WITH A PARTNER)

This exercise is very similar to Exercise 24, but it takes place in the bathtub, and clothing is not

recommended (not even a swimsuit). Fill the tub the way you would normally do when taking a bath with your partner. If you have never bathed with your partner, now's the time to start. Sit in the tub with your partner in front of you, both of you facing forward. You don't want to look each other in the eyes. That means you want to see his back, not his face.

Using your index finger as though it were a pencil, start writing your favorite sexy words, letter-by-letter, on your partner's back. Write slowly, letting him guess each letter. If he guesses right, say yes. If he guesses wrong, say no and write it again. When you have finished spelling the word, say, "That's it."

After you've written lots of sexy words, try writing some of your sexy sentences. If you're feeling creative, make up some new sentences to fit the moment (for example, "Is that a bar of soap I just felt, or are you happy to see me?")

Feel free to switch positions in the tub and switch roles at any time if your partner is interested in doing a little of his own spelling.

Exercise 27: Tongue-Tied

(20–30 MINUTES, WITH A PARTNER)

This exercise is an interesting variation on Exercises 25 and 26. There's just one catch: Instead of using your index finger to spell out your words, try using your *tongue*.

One word of caution: If you're in the bathtub, make sure to rinse off any soap that's on his back, or your back, before anyone gets a tongue lashing.

Learning to Spell and Speak

It's time to get a little more daring, that is, a little more verbal. The next two exercises are going to help you get the words out with a minimal amount of pressure or embarrassment. To help do this, we're going to start with some of *his* words—the words *he* has always wanted to hear *you* say. Since he'll be the one doing the choosing, you're virtually guaranteed that the first sexy words out of your mouth won't make him faint. Once your partner has played his cards, so to speak, and revealed just how sexy *his* thoughts are, he's going to be a lot more receptive to your thoughts and your words, and you're going to feel a lot more comfortable saying them out loud.

Exercise 28: Little Secrets
(40 MINUTES, WITH A PARTNER)

This exercise begins with you lying in bed, face-down. If you wish to remain fully clothed, that's fine. If you want to take your top off, or take everything off, that's fine too (though I recommend you leave the sheets on). Your partner should dim the lights, then sit or lie next to you on the bed. Using his index finger as a pencil, your partner's job is to spell out on your back, letter-by-letter, sexy words that *he* has always wanted to hear *you* say. After he has finished spelling each word, you have two options. You can either softly say the word out loud *or* if you are uncomfortable with his choice, you can say "pass."

After ten minutes, switch positions. Think about the words you have always wanted to hear your *partner* say. Spell them out on his back, letter-by-letter, using your index finger.

He also has the option to say the word out loud or to say "pass."

Switch positions again. This time, let your partner spell out sexy sentences he has always wanted to hear you say. If the sentence appeals to you, say it softly out loud. If it makes you uncomfortable, say "pass." After ten minutes, switch one last time and start writing sexy sentences you have always wanted to hear your partner say to you. Once again he has the option to say the sentence aloud or to say "pass."

~

Exercise 29: Sweet Nothings
(20–30 MINUTES, WITH A PARTNER)

This exercise begins with your partner lying in bed, face-down. You should be sitting, or lying on your side, very close to him. Your partner has the option of being completely clothed, completely undressed, or anything in between, and so do you.

Think about all of those sexy words and sentences you've been aching to say to this man. If you need to refresh your memory, check your notebook before you start the exercise. Using your index finger like a pencil, write one of your favorite words, letter-by-letter, on your partner's back. When you have finished spelling it out, lean over and *whisper it into his ear.* Choose another

word. Spell it out, then lean over and whisper it into his ear. Proceed in this fashion through at least a dozen words.

Now try some bad-lib sentences from Chapter 11 or some of your sentences from Chapter 5, Exercise 3. Write the complete sentence out, letter by letter, word by word, then lean over and whisper the entire sentence into his ear. Do this with at least five or six of your favorite sexy sentences.

There is one very important requirement for this exercise: *Your partner must remain silent and passive the entire time*. Even if he thinks he is being helpful, unwelcome feedback can disrupt the mood and make you clam up in a hurry. He needs to stay quiet, and stay still, lying face-down on the bed.

Exercise 29 is one of the most important exercises in this book. I encourage you to repeat it many times over the next few weeks or months. Try new words and sentences each time, or return to old favorites if that's your preference. This exercise will help build up your courage and your confidence. As you get more and more comfortable talking to your partner, start to experiment with volume and tone the way you did in some of the earlier exercises in this book.

If your partner wishes he could be more verbal too, and seems impressed by your progress, try switching roles and let Exercise 29 get the words flowing from his mouth!

Who Said That?

When you're trying to talk sexy to your partner for the first time, sometimes it's easier to break the ice if the words are neither yours nor his, but the property of some third, neutral party such as a poet or author. Many people feel less responsible for the words that others have written, and as a result, they have an easier time saying these words aloud.

As you already know (see Exercise 5: Arabian Nights, questions 2 and 5), there is an unlimited supply of very sexy poetry and prose out there, written by everyone from commoners to kings. Some of it is loving, some of it is sensual, some of it is provocative, and some of it is downright pornographic. But all of it can be a turn-on. What style appeals to you most? Are there other styles you also might find titillating? The final exercise in this chapter will give you a chance to share all of your favorite material with your partner, and possibly discover a few new favorites as well.

Exercise 30: Bedtime Stories

(20–40 MINUTES; WITH A PARTNER)

To do this exercise, both you and your partner need to be lying comfortably in bed. Both of you will probably feel most comfortable wearing bedtime apparel (robes, lingerie, pajamas) Set the mood you desire with candles or soft light, but be certain there is enough light to enable you to read. For the next twenty minutes, you are going

to read some of your favorite sexy poetry and/or literature to your partner. Your partner's role is simply to listen.

Are you feeling more confident? Are you feeling very sexy? Then consider reading your partner the fantasy fill-ins you created in Exercises 20 and 21.

After twenty minutes, switch roles and let your partner read to you if he so desires. Do you have something specific you want him to read? Ask him, but with the understanding that the choice is ultimately his.

Exercise 30 is more than just an effective ice-breaker. For many couples, it is a perennial favorite. If you are going to repeat this exercise, which I highly recommend, try varying your reading selection. Experiment with as broad a range of material as possible—from soft and subtle to explicit and hard-core. Try to expand your horizons; you might be surprised and delighted by the things you learn about your own sexuality (and your partner's too!).

Body Talk

How well do you really know your partner's body? How well does he know yours? What do you want to tell your partner about his body? What do you want to hear him tell you about yours? Couples can be together for years and years, yet never talk to each other about their bodies. Some couples barely look at each other's bodies. In my opinion, that has to change—and it has to change now.

If you've read the Song of Solomon you know that talking about the body is an incredible turn-on. Even in biblical times, people knew: Love thy body, and thy body gets loved. Which leads me to my next question: Are you ready to fall in love—to fall in love with your partner's body, and your own body too? Then this is the chapter for you.

The six exercises in this chapter are all power-

ful body-image exercises designed to help you and your partner get reacquainted. As always, these are demand-free exercises.

Exercise 31: Lip Service
(30 MINUTES, WITH A PARTNER)

This exercise begins with your partner lying comfortably in bed, face-down, fully clothed. You can dim the lights, but leave enough light to see him clearly (before you continue, make sure your partner is comfortable with the lighting).

Sit or lie next to your partner on the bed. Study his neck, his hair, and his ears. Now talk to him about them. How do they excite you? What do they make you think about? What do they look like? You can be very loving, very dirty (which, in my opinion, is also very loving), or anything in between. For example, you might say, "Your neck is so strong I get turned on just looking at it" or "Your hair is so soft I just want to stroke it" or "I want to bite your earlobes and whisper dirty words in your ear." Don't *do* any of these things—just talk about it. Your partner needs to remain both quiet and passive.

Now remove his shirt. Study his back, his shoulders, his arms, and his hands. Talk to him about all of them, one part at a time. You might say, for example, "Your hands are so powerful I can't wait to feel them wrapped around me."

Finally, remove his trousers and his underwear. Study his behind, his calves, his ankles, the soles of his feet, and finally, his toes. Talk to him about all of these parts of his body, one at a time.

After you have done this for fifteen minutes, your partner should turn over so that he is now lying on his back. Once again, start from the top and slowly work your way down.

Start by studying your partner's face—his eyes, his nose, his mouth, his chin. Describe them to him. Tell him how each part turns you on. Next, study his throat, his chest, and his stomach. Keep talking. Move on to his hips, then to his penis and testicles. Study them carefully and talk freely. Finally, take a good look at his thighs, his ankles, his feet, and his toes and talk yourself out.

Wow! Was that sexy or what? It may be hard to resist having sex after an exercise like that one, and if you must you must (sigh). But don't forget that we're just getting started. Now it's your turn to have your body celebrated. And I don't care *how* the saying goes—in this case, flattery will get him *everywhere*.

Exercise 32: Doctor, Doctor

(30 MINUTES, WITH A PARTNER)

If you are very sensitive about having your partner look at your body, adjust the lighting in the room to make yourself as comfortable as possible, while still leaving enough light so that your partner can see you. Now lie comfortably in bed, face-down, fully clothed.

This time, it is your partner who is going to do the talking. You are to remain quiet and pas-

sive, simply letting yourself appreciate everything he has to say.

Your partner's assignment is to study the various parts of your body, describe them to you in the sexiest language he can muster, and talk freely about how each part turns him on. He should begin by studying and talking about your hair, your neck, and your ears. How do each of these excite him? He might want to say, for example, "Your neck is so smooth and so soft I want to kiss it and bite it" or "I want to put my tongue in your ear and let you feel the warmth of my breath."

Now let your partner remove your blouse so that he can study, fully appreciate, and talk to you about your shoulders, your back, your arms, and your hands. It is important that he takes his time; if you feel he is rushing, let him know. If your partner is doing his job to your satisfaction, let him now remove your skirt or slacks, stockings, and panties. Proceeding slowly and intently, he should study your buttocks, hips, thighs, and calves, talking oh-so-sexy as he goes. Next come your ankles, then the soles of your feet, and finally, your toes.

After fifteen minutes, turn over and lie comfortably on your back. Starting with your face—your eyes, nose, mouth, chin—your partner should spend the next fifteen minutes *slowly* working his way down your entire body until he has reached your toes. He should always try to make his descriptions as sexy as possible, letting you know how truly exciting each part of your body is. He might want to say such things as: "Your thighs are

so soft they make me hard" or "Every time I look at your nipples I want to put them in my mouth."

Remember: You're not supposed to *do* anything, just listen, and he's not supposed to do anything but talk. Don't break the rules!

Don't Dress . . . Caress

Remember the caress you learned in Chapter 7? In Exercise 33, we're going to bring it back for an encore. But there's a slight twist: This time, it's your partner who is going to be doing the caressing—and he's going to be caressing *you*.

Exercise 33: Smooth Operator

(40 MINUTES, WITH A PARTNER)

After adjusting the lighting to your satisfaction, lie comfortably in bed, face-down. It is preferable, but not essential, to do this exercise in the nude.

Your partner should sit right beside you. Starting at the top of your neck, he is going to perform a full-body massage, gently stroking the back of your body for a full twenty minutes. He needs to work his way down your body ever so slowly, focusing intently on each part of your body as he proceeds. If you are not wearing any clothing, I recommend using the lubricant of your choice to facilitate and enhance his massage.

As your partner is performing his body caress, your job is to talk and talk and talk, saying what-

ever sexy thoughts or feelings come to mind. Let it come out in a stream of consciousness and try not to censor anything. Your stream might include moans, grunts, words, sentence fragments, random thoughts, descriptions of your body, descriptions of what he is doing, descriptions of what you are feeling, or descriptions of fantasies that are being triggered by his caresses. After twenty minutes, turn over so that you are lying on your back. Your partner should resume his caress, slowly working his way down the front of your body in the same focused fashion. When he reaches your genitals he needs to be extra slow and pay special attention. Once again, your job is to express whatever sexy thoughts and feelings come to mind in an uncensored stream of consciousness.

Exercise 34: Slippery Devil
(40 MINUTES, WITH A PARTNER)

This exercise is just like Exercise 33. Only this time, you will be performing a full-body caress on your partner while he responds by talking in a stream of consciousness.

Begin with your partner lying on his stomach and slowly work your way down from tip to toe. If he is naked, which is preferable, use plenty of lubrication. Encourage him to not censor any of his thoughts or feelings.

After twenty minutes, have him turn over and resume your caress, paying special attention to his genitals.

~

"Mastur" the Possibilities

Masturbation. The very mention of it conjures up all kinds of memories, thoughts, feelings, and judgments. There are very few acts that are more intimate than masturbation. For most of us, it is how we first experienced ourselves as sexual beings—how we learned about our body, and the unique way it responds to being touched. Almost everyone has masturbated, and the vast majority of us haven't stopped. Yet there are very few of us who are truly comfortable sharing this experience with a partner.

Masturbating in the presence of a partner is truly one of the most special things a couple can share. It can also be an invaluable learning experience. Truth is, we all have something to learn from watching our partners masturbate, and vice versa. In exercises 35 and 36, both of you will get that chance.

Exercise 35: Someone's Watching

(30 MINUTES, WITH A PARTNER)

Lie in bed with your partner and make yourself comfortable. If you like, let him cradle you. Close your eyes and begin stimulating yourself the same way you would if you were alone. Try not to think about the fact that your partner is watching you. Let yourself go, trying to make the experience as intense as possible. Feel free to talk to yourself or to express yourself with sounds.

After fifteen minutes, switch roles. Watch as

your partner pleasures himself the way he likes most. He should keep his eyes closed and stay focused on his own sensations.

After both of you have had a turn, talk to each other about what this experience was like. Try to be as honest as possible, even if it means talking about how nervous or embarrassed you were.

Note: If you are feeling self-conscious about being the first one to masturbate, and your partner isn't eager to volunteer either, you may find it easier to masturbate together the first time you do this exercise. You won't be able to do much observing, but at least you will be able to break the ice around the issue of masturbation.

Exercise 36: Wish You Were Here

(30–40 MINUTES, WITH A PARTNER)

This exercise begins just like Exercise 35. This time, however, as you start to masturbate, talk to your partner about your fantasies. For example, you might start by saying, "I wish we were alone on a tiny island, with the smell of tropical fruit and flowers filling the air" or "I wish we were in the shower, with you soaping up my body and telling me how much you love me." (If you're short on ideas, review your fantasy fill-ins from Exercises 20 and 21, and your answers from Exercise 3 in Chapter 5.)

Continue your fantasy, making it as elaborate and full of detail as possible. Tell him what you

wish he was doing to you at that very moment, and what it would feel like; also tell him what you wish you were doing to him, and what that would feel like. For example: "I would start kissing your stomach and watching your penis swell" or "As you unbuttoned my blouse and started massaging my breasts I would run my fingernails up and down your back."

After fifteen or twenty minutes, switch roles. As you listen to your partner's fantasies, try not to feel threatened. If your fantasies don't concur with his, that's okay. Remember that these are not demands, they are only fantasies—just because he says it doesn't mean you have to do it.

If you are hesitant about sharing your favorite fantasies with your partner, create one now that doesn't make you feel too vulnerable. As the two of you become more comfortable with each other, you can experiment with sharing fantasies that are more and more revealing. You might even enjoy talking about acts that you consider taboo just to see how that feels.

One more thing to remember: This is fantasy sharing, not fantasy acting-out. You are only telling stories; this is not the time to make those stories come true.

Do It!

D O you think like an animal but still act like a vegetable? Then this is the chapter you've been waiting for. If you have been doing all of the exercises faithfully, you should have more than just a new vocabulary by now; you should have a lot more confidence too. Now it's time to really let go. It's time to put all those words into action—to start asking for what you really want, and start getting it.

The Roles of a Lifetime

The exercises in this chapter bring together all of the skills you have learned so far. In each of these exercises, there are two roles to be played, the passive role and the active role. If you are assuming the active role you are the boss. You will be

asking your partner to perform various loving, sensual, and erotic behaviors, telling him or her everything you want him or her to do. The active partner can also do whatever she or he wants to do, as long as she or he lets the passive partner know in advance and the passive partner agrees.

When you are the passive partner, your job is to simply do whatever your partner asks (You'll notice a slight modification in Exercise 38), providing it is not something that you find unpleasant. The passive partner *always* has the option of saying "I don't want to do that right now." You do not need to explain or justify this decision. If you want to discuss it after the exercise is over, that's fine, but during the exercise the active partner must accept your decision, and move on to another request.

I don't know what else to say but, "Let the games begin."

Exercise 37: Come and Get It

(40–60 MINUTES, WITH A PARTNER)

This exercise begins the moment you and your partner enter the bedroom (or whatever room you choose for the exercise). For the first twenty to thirty minutes, you will play the active role and your partner will play the passive role.

As the active partner, you will start by making your first request. You can ask for anything you can think of, but you need to be very specific. For example, you might start by saying: "Please light some candles" or "Please take off everything but your underwear" or "Please take off my shoes and

massage my feet." Nothing can happen until you ask for it. Your partner can refuse your request, but all of the choices are yours.

It helps a great deal to stop and think for a moment before you make any request. Think about what it is you want at this very moment. Do you want him to take care of you in some fashion, or do you want to do something for him? Do you just need to be held for a while or are you ready to jump in to something down and dirty? Think about *your* needs. Don't try and guess what he might want—he'll get his chance soon enough. If you don't know *what* to ask for, go back and review your answers in Chapter 5, Exercise 3.

If your partner accepts your request, but he is not doing exactly what you want, give him gentle, but straightforward directions until he gets it right. If it's something about the way he's touching you or *not* touching you, for example, guide his hands or demonstrate with your own hands.

After twenty or thirty minutes, switch roles. Remember that as the passive partner you can refuse any request your partner makes, and you are under no obligation to give an explanation during the exercise. If you both want to talk about your decision later, that's fine, but right now he needs to move on and make another request.

～

The next exercise is similar to Exercise 37, but it has a few interesting twists that heighten erotic tension while giving you additional opportunities to practice your new communication skills.

Exercise 38: Say Please . . .

(40–60 MINUTES, WITH A PARTNER)

This exercise, like Exercise 37, begins the moment you and your partner enter the bedroom (or whatever room you choose for the exercise). For the first twenty or thirty minutes, you will play the active role and your partner will play the passive role.

As the active partner, you will start by making your first request. As in Exercise 37, you can ask your partner (who is first playing the passive role) for any loving, sensual, or erotic act you can think of. Remember to be as specific as possible.

The passive partner always has the right to refuse any request, without explanation. But this time there's more. In this exercise, the passive partner also has the right to respond verbally with provocative statements such as: "Ask me again," "I didn't hear you," "Say it louder," "Say please," "Beg me." This erotic taunting must always be done in a way that is playful and loving; it must never be done in a way that is demeaning or full of ridicule. In addition, the passive partner can only play with the active partner's request if he or she has every intention of ultimately responding to that request. If the request is unacceptable, it should always be dismissed immediately.

After twenty or thirty minutes, switch roles. (Though, if your partner has played his first role well, you might be rather confused right now about who's active, who's passive, and who's really in control.)

Remember all of those sexy things you said you wish you could tell your partner? Well, the time has come. In the next and final exercise in this chapter, we're going to incorporate the stream of consciousness feedback technique you learned in Exercises 12 and 33 with the active/passive role playing you just practiced in Exercises 37 and 38. The combination, as you will soon see, is lethal. In my opinion, it's also the sexiest exercise in this book. I've forgotten my own name doing this exercise!

Exercise 39: Talk Dirty!

(40–60 MINUTES, WITH A PARTNER)

This exercise begins just like Exercise 37. But this time, once you have made a request of your partner and he starts to comply, it is your job to fill his ears with as much sexy feedback as possible. You want to do this in a stream of consciousness fashion, trying very hard not to censor yourself. Your goal is to give him a blow-by-blow description in the sexiest possible way, of how everything he is doing is making you feel. You can do this with dialogue, sounds, or a combination of the two. Just let it out. And don't stop!

After twenty to thirty minutes, switch roles and give your partner a chance to talk really sexy to *you*.

For a variation on this, try incorporating the playful taunting technique you learned in Exercise 38. If you are playing the active role, let your

partner know how this taunting is making you feel (For example: "You're making me crazy . . . I have to have you inside of me now!"); then let him know what it feels like when you finally get what you're begging for. Don't forget to switch roles after twenty or thirty minutes.

Exercise 39 is, in many ways, a milestone. If you were going to school to learn how to talk sexy to the one you love, this exercise could easily have been your final exam. By bringing together so many new skills and ideas and putting them into practice, you have boldly gone where many wish they could go, but few actually dare. Just think—only fourteen chapters ago you were a wallflower, probably wondering if you'd ever be able to say a single sexy syllable. Today, however, you are a master linguist.

But don't pop the champagne cork and toss your cap yet. I think you've got what it takes to graduate from this course of study with honors. And that's what the next two chapters are all about.

Sound and Fury

YOU'VE done a lot of talking. I think it's time to learn when not to talk. Let's face it, at certain moments during lovemaking, words *can* get in the way. And sometimes there just are no words to describe the kind of exquisite excitement you are feeling at that moment. Don't let that discourage you though. After all, there are sounds—wonderful sounds—sounds that add a whole new dimension to lovemaking.

Sounds are a powerful erotic tool that can heighten pleasure, magnify feelings, and even intensify orgasm. At the beginning of this book, in Exercise 8, you got your first taste of this kind of magic. I think that now you're ready for a heaping helping.

The Sounds Of Pure Pleasure

Do you know what happens to your body when you have an orgasm? Perhaps I should rephrase that question. I'm sure you know what an orgasm *feels* like, but do you know what is actually happening, physiologically, to your body, as you approach, and ultimately reach orgasm?

Besides making you feel like a million bucks, the orgasm process has your body doing all kinds of things: Your heart is beating faster, blood pressure is increasing, breathing is both faster and heavier, muscles are contracting. It's a real scene, but in a nutshell, your body is trying to release energy.

Releasing sound is also releasing energy; that's one of the reasons why all of the talking you've been doing so far has felt so darn good. Fact is, I firmly believe that making noise does more than just enhance orgasm; I believe that making noise is actually *necessary* to have a full orgasm. I don't care if it's grunts, cries, shouts, words, sentences, or full paragraphs . . . if you're not making noise, you are preventing your body from releasing energy and holding back the power of your own orgasm. It's almost criminal.

In the next four exercises, we're going to focus all of our attention on making amends for our energy mismanagement, and learn how to make the "Big O" bigger and better than ever.

Exercise 40: Noise Machine

(15 MINUTES, WITH A PARTNER)

In this warm-up exercise, you and your partner are going to help each other make a wide

variety of noises that express human emotion. There is no physical contact of any kind in this exercise, and both of you should remain fully clothed.

Start by practicing loud, deep breathing together. Breathe faster and even louder. Now grunt together. Then moan together. Groan. Cry. Giggle. Purr. Laugh. Growl. Shriek. Howl. Bay at the moon (werewolves are half-human, aren't they?).

You want to get totally connected to each emotion, the way a good actor would. Focus intently and really let yourself go. The louder the better. Remember that the couple that bays together stays together.

Now rest your throat for a few minutes before proceeding to the next exercise.

~

Exercise 41: When Harry Met Sally

(20 MINUTES, WITH A PARTNER)

This is a play-acting exercise with you and your partner taking turns. Let's start with you. The role you are auditioning for is that of a highly orgasmic woman in the throes of orgasm. What would she sound like? What would she look like? Dig deep into your theatrical soul and imitate this woman as convincingly as possible. Your goal is to bring the house down. If you need a role model, think about Meg Ryan's famous restaurant scene in the film *When Harry Met Sally*.

Now it's your partner's turn. The role he is auditioning for is that of a man who is in the

throes of the orgasm of a lifetime. What would that man look like? How would he be breathing? What would he be saying? What noises would he be making? How would his body be moving?

When you have both auditioned, try switching roles. What does your partner think a highly orgasmic woman would look and sound like during orgasm? What do you think that man would sound and look like? Give it a try. This role reversal may seem like it's just for laughs, but it's really intended to help you learn a few new things about the opposite sex, and feel the differences in male and female orgasm.

∽

Exercise 42: Desire

(40 MINUTES, WITH A PARTNER)

Lie comfortably in bed and let yourself relax. When you are ready, ask your partner to begin a body caress (the way he learned in Exercise 33).

This time the goal of your partner's caress is to bring you to orgasm. As he is performing this caress, you want to give him as much guidance as he requires, using sexy language wherever possible.

Your goal in this exercise is to amplify the experience of orgasm using any combination of noises. As you feel yourself approaching orgasm, focus intently on all of the pleasurable sensations in your body. Now try to express those sensations with noise: breathe harder, moan louder, groan louder, squeak, squeal, cry out, shout—whatever

feels good. But don't hold anything in. Keep in mind the role model you created in Exercise 40.

After you have had your orgasm be sure to release as much postorgasmic noise as possible (purring, heavy breathing, weeping). Then switch roles and give your partner a chance to sound off.

The Quest For Fire

Why do we have sex? Because we can, so the joke goes. If you stop and think about it, which few people ever do, there are *so* many reasons to have sex: to procreate, to express love, to express passion, to avoid housecleaning—the list is endless. But one of the most important reasons we have sex *so much* is because it is a basic instinct.

As human beings, we sometimes struggle to view ourselves as part of the animal kingdom. The final exercise in this chapter is something fun we've been doing for years at the clinic where I practice. It may seem a little silly at first, but it really helps people get back in touch with their ability to enjoy sex as a basic animal activity.

Exercise 43: Wild Thing

(30–40 MINUTES, WITH A PARTNER)

This is also a play-acting exercise where partners take turns in the active and passive roles.

In this exercise, it is the active partner's job to "act like an animal" while caressing the passive partner. Acting like an animal means just that— you want to grunt, groan, bark, yip, growl, squeal, roar, kiss, lick, suck, nibble (gently), chew

(gently), and bite (very gently). You can jump up and down, run around the room, swing from the chandeliers, or hide in the plants. The only thing you *don't* want to do is talk. For this exercise, you may prefer to let your partner take the active role first. Then, after fifteen or twenty minutes, be sure to switch roles and give yourself a chance to connect with the animal inside of you. (When you're both done, the two of you may want to groom each other for a while.)

Playing with Fire

THE hardest work is over, but the thrills have just begun. Now that you've unleashed the beast within, it's time to let that beast roam free and discover your personal fantasy threshold. How wild *are* you? How hot can your language really get? How far can you go and still get home in time for dinner? Questions, questions, questions. Do you think that you're ready for the answers? I do.

I think it's time to find out exactly what you've been hiding from yourself for all of these years—and what your partner's been hiding too. And to help make this possible, I'm going to use this final chapter to teach you some of the games I teach my clients once they've learned to talk sexy to their partners. I love these games. They're fun, they're easy, they're expansive, and they

don't have lots of little pieces that get lost under the couch. Frankly, some of these games are quite risqué, and not for those who easily blush; but they'll have you sizzling from sun up to sundown.

We'll start with three of my favorites.

Exercise 44: Who Said That?

(20–30 MINUTES, WITH A PARTNER)

This exercise begins with you and your partner lying together comfortably in bed. Clothing is optional, but in this exercise I think you'll have more fun without any.

If your breasts could talk, what would they be saying to your partner? If his penis could speak, what would it be telling you? The object of this exercise is to create dialogue for all of the sexy parts of your body and your partner's body, one part at a time. Let's say, for example, that you start with his ear. If his ear could talk, it might say, "Put your moist tongue inside of me" or "I want to feel the warmth of your breath coming from your soft lips." As the two of you explore your bodies together, take turns creating dialogue for each part. Try to leave no parts uncharted. If you can't think of anything sexy, say something silly. The goal, as always, is to keep talking.

～

Exercise 45: Private Collection

(30–40 MINUTES, WITH A PARTNER)

You know those catalogs and magazines you wrote about in Chapter 5, Exercise 5? How would

you like to share some of those sexy tidbits with your partner? Curling up next to the man you love and browsing through your favorite lingerie catalogs, sexual paraphernalia catalogs, and sexy magazines (please, try to avoid any that could make him jealous) can be a real turn-on. As you flip through the pages, talk to your partner about the things that excite you, and how they make you feel. Does your partner have his own titillating collection of favorites? Encourage him to show you a few of the gems that he may have tucked away, and to tell you what makes them so special.

∼

Exercise 46: Field Trip

(2–3 HOURS, WITH A PARTNER)

Go with your partner to the museum in search of various sexy works of art. Whenever you find a piece that turns you on, stop in front of it and study it carefully. Then, in your best museum whisper, tell your partner how turned on you are, being as specific and explicit with your language as possible. For example, you might say something like, "Seeing that couple in the photograph embrace makes me want to kiss your neck while you grab my breasts."

Try to keep a very sincere museum expression on your face the entire time—being bad while looking innocent adds to the titillation. Your partner should play the role of the good listener and remain silent throughout your commentary.

At some point, switch roles and let him find some artworks that he wants to talk about.

∼

Surprise, Surprise

In the beginning of this book I told you that when it comes to sex, I'm not a big believer in surprises. I meant it. But at the risk of contradicting myself, I must confess that there are those *few* exceptions where a sexy surprise is a surprise most welcome. I think you'll understand what I mean when you read through the next two exercises.

Exercise 47: Good Morning

Using his favorite color lipstick, write a short, sexy message to your partner in large letters on the bathroom mirror (For example: "I want you" or "I need it tonight"). The best times to do this are in the morning before you leave the house (if you get up before he does) or in the evening before he gets home. Now think about what you're going to get once he gets the message. By the way, if his favorite color lipstick costs a small fortune, use a reasonably priced facsimile.

∼

Exercise 48: While You Were Out

Plant a sexy message in your partner's car, briefcase, lunchbag, or wallet. Make sure it's in a place that only he could discover. The message should be some variation on the theme of: "When

you get home tonight I'm going to . . ." For example: "When you get home tonight I'm going to bathe you from tip to toe, wearing my sexiest lingerie. Then I'm going to strip for you until you get so excited you can't keep your hands off of me." Now sit tight till he comes home, and wait to see the magical effects of your handiwork.

∽

Is the Caller There?

I think the telephone was invented for people who love to talk sexy (and the telephone bill was invented to stop us from getting too carried away). In the next three exercises, I'm going to show you a few creative ways that the telephone company can help you stay intimately connected with your loved one. Please note: If the privacy of your telephone connections is not a certainty, I discourage you from trying any of these exercises. Do not use a cellular phone.

This first exercise is a surefire way to turn an ordinary day into a day to remember with just the touch of a few buttons.

∽

Exercise 49: It's for You

Pick up the telephone and call your partner. When you are certain it is him on the line, tell him something *really* sexy, and then hang up. You might say, for example: "I just wanted you to know I'm not wearing any underwear" or "If I

was there right now I'd let you make love to me on top of your desk" or "I can't wait till you get home tonight and I can unzip your fly." Get the picture? Good. Encourage your partner to call you with his sexy messages too.

This second exercise has been made possible by years of research and sophisticated microchip technology.

Exercise 50: Beep, Beep

Does your partner have an answering machine or voice mail service that only he has access to? If he does, leave him a really sexy message when he'd least expect it. Here's an example of a message that will change a man's mood for a while: "I just called to tell you that I'm thinking about your beautiful stiff penis."

After a week or two (or less, if you can't wait), leave another sexy message. Once your partner retrieves a few of these sexy messages from you, hopefully he'll "get the message" and start entertaining you with sexy little surprises of his own. If he doesn't, you can always ask him.

Living in the jet age isn't always easy. Do you or your partner ever have to part company overnight because of the demands of business or family? It gets lonely on the road, but, as you will soon discover in this third and final exercise, it feels a lot less lonely if you and your partner can talk each other through an orgasm before bedtime.

Exercise 51: Phone Home

Call your partner and, in your sexiest voice, tell him how much you miss him. Tell him how much you want him to have an orgasm before he goes to sleep, and that you'll "talk him through it" if he'll do the necessary work on his end (you may not even have to say this last part, since he may have already started on his own once he heard your voice).

Now tell him in the greatest of detail what you would be doing with him if he were in bed with you right now. Tell him what you're wearing (or *not* wearing). Tell him how you're touching yourself, and how that feels. Describe your body to him in detail. Talk to him about his body. Tell him how much it turns you on, and how you wish you were touching him. Use the sexiest language you've got. Now ask him what he's doing right now as he's listening to you talk. If he tells you that he's touching himself, ask him to describe that to you.

You may want to take turns verbally stimulating each other, or you may opt for simultaneous stimulation. Either way makes for very pleasant dreams.

~

Forever After . . .

There aren't many times that I've been at a loss for words, but frankly, I'm talked out. It is my sincerest hope that the exercises I have presented in this book will help you and your partner create

a never-ending story, giving you a blueprint for a lifetime of talk that will get sexier year after year.

Most of the exercises in this book never *stop* being sexy—don't *you* stop. As you may have already discovered, the greatest thing about talking sexy is that the more you do it, the sexier it gets. Some days, you just don't know *what* is going to come out of your mouth. The only thing you do know is that it will be steaming hot. So be adventurous, be creative, be crazy, be dirty, be playful, be daring—and, for the rest of your life, be the sexy woman you were always meant to be.

Epilogue

I T'S ten o'clock on a Saturday night and Sharon and her husband, Richard, have just returned home from a romantic dinner. At this moment Sharon is looking at her husband's body, and she's wondering how she can tell him that she's been having sexual fantasies all day. She would like to be able to tell him what she has been thinking about. She would like to be able to describe to him the way she feels about his body, his lips, his hands, and his penis. She would like to be able to tell him how she wants to make love right now, and how turned on she's feeling. *And now she can!* Suddenly, a big, sexy smile breaks out across Sharon's face. Dinner may be over, but dessert is about to be served. Life sure has changed since Sharon learned how to talk sexy to the one she loves.

Appendix: For Men Only

IF you have never talked sexy to a woman or had a woman talk sexy to you, you may be feeling somewhat uncomfortable with the concept. Such feelings are perfectly normal and understandable. It is hard for many people to imagine how a few changes in someone's vocabulary can inject thousands of volts of electricity into lovemaking. After all, how sexy can a bunch of words really *be*? And how sexy can a bunch of *exercises* be?

Although talking sexy may not sound very exciting or erotic to you right now, the fact is that the techniques I offer in this book can unleash a level of passion, pleasure, and desire that few couples are ever lucky enough to experience. Hard

to imagine, perhaps, but you won't have to rely on your imagination for very long. Once the words start to flow, so does the excitement. After that, the only regret you're likely to have is that you waited this long to try.

Still, I would not feel I was doing my job as a sex therapist if I did not attend to possible concerns you might be having right now and do my best to mitigate them. For this reason, I'd like to offer you some guidelines.

Get Ready for Wonderful Changes

Your lovemaking is about to change, and change dramatically. The woman you always thought you knew is about to surprise you in a very big way. And you may have a few surprises of your own. Once people start talking sexy, they discover all kinds of powerful erotic feelings inside of themselves they never even knew were there. That's really exciting, but it can also be unsettling. Change is always kind of scary, and that has to go double for changes in lovemaking.

Now I know you love your partner very much. I'm not psychic. I just recognize that any man who is reading this book at the request of his partner must love that woman a great deal. Love means trust. In a loving relationship, you can open up to each other in ways you could never open up to someone you didn't trust. I want to do everything possible to support that love and that trust, and to strengthen it. But I need your help.

If there's one thing that stops men from getting excited about talking sexy, it's their fear of change. And if there's one thing that can minimize that fear, it's getting fully involved in the process. Now, you don't have to read this book to reap the benefits of what your partner is about to learn, but here's why I think you should:

In the beginning of this book I make it very clear that I'm not a big believer in surprises when it comes to sex. I want you to know what to expect and when to expect it. At the very least, you ought to have the opportunity to know exactly what your partner is about to learn. Reading this book is the best way for you to minimize unpleasant surprises and prepare for everything that is coming your way. It's also a great way to get you more excited about the process. Even if you don't actually work on any of the exercises, leaving all of that to your partner, just reading through them can be a pretty big turn-on. Now let me tell you what can be a pretty big turn-off: sexual pressure. That's why . . .

Never Forget That They're Only Words

Talking sexy may sound like a pretty harmless way to enrich your lovemaking, but it can also lead to conflict if your partner's new vocabulary is misinterpreted. Talking sexy, more than anything, is a way to convey *mood*. Your partner will be expressing her feelings, her desires, and her fantasies. She will not be issuing demands—nor will you—and it is crucial that you understand, believe, and accept this.

Before the talking starts, it is crucial that you both agree that nothing either one of you says, asks for, or begs for has to be acted on, ever. *Nothing.* This agreement will leave you completely free to explore your eroticism to its fullest extent without ever feeling pressured to deliver the goods. If you cannot agree to these terms, I must discourage you from going any further.

I must also discourage both you and your partner from going any further if it is clear to you that talking sexy is something you simply do not want. Reading through the book, or even skimming it, could help you make that decision. Talking sexy is not the only way to spice up your lovemaking (you may not even *want* to spice up your lovemaking), and if the thought of it disturbs you, scares you too much, or turns you off, the time to let your partner know is *now*. This will minimize hurt feelings, anger, and confusion for both of you.

You Don't Have to Say a Word (But I Wish You Would)

I want you to read this book to get you prepared, to avoid unpleasant surprises, and to minimize conflicts, but those aren't my only reasons. More than anything, I want you to read this book because I want *you* to start talking sexy too!

It is incredibly exciting to have a partner who likes to talk sexy, and for you, that may be more than enough. Maybe you're the "strong, silent type." Maybe you're more than content to just sit

back and listen to what your partner has to say (and say, and say, and say). As long as you are doing this in a loving and accepting way, it's perfectly okay to play the role of passive participant. But believe me when I tell you that talking sexy is *far* more exciting when two people start talking to each other. Let me try to explain.

Excitement is contagious. Have you ever noticed, for example, how an argument heats up when both partners are going at it? Have you also noticed how it tends to fizzle out when one partner refuses to get involved? Well, it's not any different when it comes to talking sexy. Nothing adds to the mix more than an enthusiastic partner. When two people are putting all of their energy into the connection, it isn't long before the temperature starts to rise. Pretty soon, you've got a chain reaction going that can shake the chandeliers. (By the way, I hate to argue with my partner. This is just an analogy, not an endorsement.)

You will notice that in Chapters 12 through 16 there are a number of partner exercises—exercises specifically designed for a couple to practice together. Now, doing exercises may just not be your thing. You may have your own ideas about how to talk sexy with your partner, and that's perfectly fine. But if you need some icebreakers, and some creative new ideas, I think these exercises will help a lot. I'm just trying to make it as simple as possible for both of you to get into the act. These partner exercises are pretty hot, and pretty sensual, but they're also a lot of fun. I hope you try them all.

Now I need to let you in on another little secret.

Do you know what I'm *really* hoping? I'm hoping that the partner exercises alone are not enough for you. I'm hoping that you want to try *all* of the exercises in this book and learn just as much as your partner is learning. And you can. While it is true that the exercises in Chapters 4 through 11 were written for a woman to practice in private, it does not take a lot of imagination to adapt them to the needs of a *man* who wants to practice in private. So don't let yourself feel left out if you really want in. Follow the entire program if you wish. Just do me one favor. If you're going to highlight, dog ear, and make notes on every page, please, buy your own copy.

Always Remember that She's Doing This for You

Right now, you've got a lot of options. You can sit on the sidelines and be supportive of your partner's efforts, you can participate in the partner exercises, or you can "go all the way," and try all of the exercises in this book. Right now, it's not important which route you choose. What *is* important is that you remember that your partner is learning to talk sexy because she cares about you and wants to be able to express that more fully. *You* are the single most important motivation for your partner's process. It is her love for you that makes her want to talk sexy. If you can remember that, I think that regardless of whether or not you participate, you've already gained a great deal.